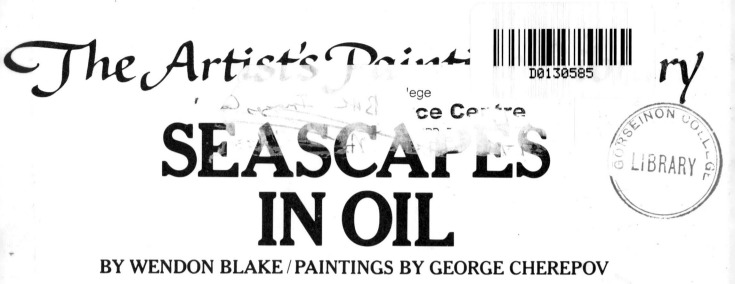

The Artist's Painting ~~Library~~

SEASCAPES IN OIL

BY WENDON BLAKE / PAINTINGS BY GEORGE CHEREPOV

This book to be returned

PITMAN HOUSE/LONDON

Copyright © 1980 by Billboard Ltd.

First published 1980 in the United States and Canada by Watson-Guptill Publications,
a division of Billboard Publications, Inc.,
1515 Broadway, New York, N.Y. 10036

Published in Great Britain by Pitman House, Ltd.,
39 Parker Street, London WC2B 5PB
ISBN 0-273-01365-3

Library of Congress Cataloging in Publication Data
Blake, Wendon.
 Seascapes in oil.
 (His The artist's painting library)
 Originally published as pt. 3 of the author's The
oil painting book.
 1. Marine painting—Technique. I. Cherepov,
George, 1909- II. Title. III. Series: Blake,
Wendon. Artist's painting library.
ND1370.B575 1980 751.45'437 80-18898
ISBN 0-8230-4729-6 (pbk.)

Manufactured in U.S.A.

First Printing, 1980

Seascapes in Oil. Perhaps because man's life first emerged from the sea, human beings in general—and artists in particular—are fascinated by the seashore. Every year, as soon as the weather is warm enough, painters set up their easels and their paintboxes on the beaches, rocks, and headlands of coastlines all over the globe. Many of them love to paint the classic drama of waves crashing against rocks and flinging sunlit foam into the sky—and this book will show you how to paint this romantic and challenging subject. But the word "seascape" means a lot more. You'll also learn how to paint so many different coastal subjects—from the graceful shapes of sand dunes to the jagged forms of cliffs looming over the water—that you'll soon discover that the landscapes of the coastline are as diverse and fascinating as any landscapes you'll find inland. Once you begin to paint seascapes (or coastal landscapes) you'll discover why so many great artists have devoted their entire lives to depicting the infinite variety and romance of sea and shore.

Why Oil? The rich, thick consistency of oil paint seems particularly "right" for painting coastal landscapes. You can actually vary the character of the paint to suit the subject. Used straight from the tube, oil color is a thick paste that lends itself beautifully to the rough brushwork and ragged textures of rocks and headlands. Diluted with linseed oil and turpentine, oil paint becomes smooth and creamy; now it's ideal for painting waves with rhythmic strokes or painting sandy beaches with long, smooth, even strokes. The slow drying time of oil paint is also a great convenience. Working outdoors under the pressure of time and changing weather conditions, you can capture the basic forms and colors of your subject with rapid, spontaneous strokes. You may want to stop there. Or you may want to take the painting home and do some more work on it, refining certain colors or adding details at your leisure. Since oil paint stays wet for several days, you have the time to start a painting outdoors and finish it indoors. Of course, you can also regard the outdoor painting as a "color study" from which you can paint an entirely new and more ambitious picture at home.

Basic Techniques. The two fundamental tools of the oil painter are the bristle brush and the softhair brush. The noted painter George Cherepov begins by showing you how these two different kinds of tools behave, individually and in combination. First you'll see how surf and rocks are painted with the rough strokes of the bristle brush, capturing the dramatic textures of the subject. Then you'll see how bristles and softhairs are combined to paint waves, which require more delicate and controlled brushwork. You'll see how brushstrokes are used to model the rounded forms of clouds and the graceful shapes of dunes. In oil painting, the traditional "working sequence" starts with thin color and gradually works toward thicker color; you'll see how this is done in a study of rocks.

Color Sketches. The color section begins with some sketches that teach us important lessons about the colors you'll find along the coastline. Light and weather can make radical changes in the colors of any subject, as you'll see in color sketches of waves, surf, rocks, sand, and skies on a sunny day and then on an overcast day. You'll see some close-ups of sections of George Cherepov's paintings, in which you'll observe how he handles thick and thin color, as well as warm and cool color, in studies of rocks, water and sky.

Painting Demonstrations. Then there are ten step-by-step painting demonstrations in which Cherepov shows how to handle the most popular coastal subjects. The first three demonstrations deal primarily with water, showing how to paint the subtle colors and rolling action of waves; the violent movement of surf; and the calm, reflective surfaces of tidepools. You'll watch Cherepov paint a salt marsh, where the sea invades the land and creates "islands" of marsh grass. Three demonstrations concentrate on weather, light and atmosphere: the brooding colors of a storm at sea; the luminous tones of a sunrise along the shore; and the delicate, mysterious tone of fog. Finally, Cherepov demonstrates how to paint the solid shapes of the coastal landscape: craggy rock formations; a majestic headland rising from the beach; and the sunlit tones of sand dunes.

Special Problems. In this last section, you'll read about how to select seascape subjects. You'll find suggestions about how (and how not) to compose a successful seascape. You'll see how light can dramatically alter such subjects as rocks and clouds. You'll learn how a knowledge of perspective can help you create a sense of space in a coastal landscape. You'll see some more close-ups of finished paintings in which various types of expressive brushwork capture the special character of water and rocks. And finally, you'll learn how to recognize different kinds of wave and cloud forms.

Color Selection. When you walk into an art supply store, you'll probably be dazzled by the number of different colors you can buy. There are far more tube colors than any artist can use. In reality, all the paintings in this book were done with just a dozen colors, about the average number used by most professionals. The colors listed below are really enough for a lifetime of painting. You'll notice that most colors are in pairs: two blues, two reds, two yellows, two browns. One member of each pair is bright, the other is subdued, giving you the greatest possible range of color mixtures.

Blues. Ultramarine blue is a dark, subdued hue with a faint hint of violet. Phthalocyanine blue is much more brilliant and has surprising tinting strength—which means that just a little goes a long way when you mix it with another color. So add phthalocyanine blue very gradually. These two blues will do almost every job. But George Cherepov likes to keep a tube of cobalt blue handy for painting skies and flesh tones; this is a beautiful, very delicate blue, which you can consider an "optional" color.

Reds. Cadmium red light is a fiery red with a hint of orange. All cadmium colors have tremendous tinting strength, so remember to add them to mixtures just a bit at a time. Alizarin crimson is a darker red and has a slightly violet cast.

Yellows. Cadmium yellow light is a dazzling, sunny yellow with tremendous tinting strength, like all the cadmiums. Yellow ochre is a soft, tannish tone. If your art supply store carries two shades of yellow ochre, buy the lighter one.

Browns. Burnt umber is a dark, somber brown. Burnt sienna is a coppery brown with a suggestion of orange.

Green. Although nature is full of greens—and so is your art supply store—you can mix an extraordinary variety of greens with the colors on your palette. But it *is* convenient to have just one green available in a tube. The most useful green is a bright, clear hue called viridian.

Black and White. The standard black, used by almost every oil painter, is ivory black. Buy either zinc white or titanium white; there's very little difference between them except for their chemical content. Be sure to buy the biggest tube of white sold in the store; you'll use lots of it.

Linseed Oil. Although the color in the tubes already contains linseed oil, the manufacturer adds only enough oil to produce a thick paste that you squeeze out in little mounds around the edge of your palette. When you start to paint, you'll probably prefer more fluid color. So buy a bottle of linseed oil and pour some into that little metal cup (or "dipper") clipped to the edge of your palette. You can then dip your brush into the oil, pick up some paint on the tip of the brush, and blend oil and paint together on your palette to produce the consistency you want.

Turpentine. Buy a big bottle of turpentine for two purposes. You'll want to fill that second metal cup, clipped to the edge of your palette, so that you can add a few drops of turpentine to the mixture of paint and linseed oil. This will make the paint even more fluid. The more turpentine you add, the more liquid the paint will become. Some oil painters like to premix linseed oil and turpentine, 50-50, in a bottle to make a thinner *painting medium*, as it's called. They keep the medium in one palette cup and pure turpentine in the other. For cleaning your brushes as you paint, pour some more turpentine into a jar about the size of your hand and keep this jar near the palette. Then, when you want to rinse out the color on your brush and pick up a fresh color, you simply swirl the brush around in the turpentine and wipe the bristles on a newspaper.

Painting Mediums. The simplest painting medium is the traditional 50-50 blend of linseed oil and turpentine. Many painters are satisfied to thin their paint with that medium for the rest of their lives. On the other hand, art supply stores do sell other mediums that you might like to try. Three of the most popular are damar, copal, and mastic painting mediums. These are usually a blend of a natural resin—called damar, copal, or mastic, as you might expect—plus some linseed oil and some turpentine. The resin is really a kind of varnish that adds luminosity to the paint and makes it dry more quickly. Once you've tried the traditional linseed oil-turpentine combination, you might like to experiment with one of the resinous mediums.

Other Solvents. If you can't get turpentine, you'll find that mineral spirits (the British call it white spirit) is a good alternative. You can use it to thin your colors and also to rinse your brushes as you work. Some painters use kerosene (called paraffin in Britain) for cleaning their brushes, but it's flammable and has a foul odor. Avoid it.

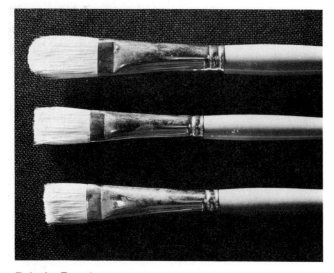

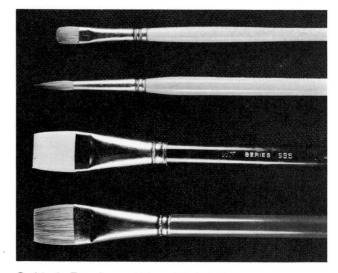

Bristle Brushes. The brushes most commonly used for oil painting are made of stiff, white hog bristles. The filbert (top) is long and springy, comes to a slightly rounded tip, and makes a soft stroke. The flat (center) is also long and springy, but it has a squarish tip and makes a more precise, rectangular stroke. The bright (bottom) also has a squarish tip and makes a rectangular stroke, but it's short and stiff, digging deeper into the paint and leaving a strongly textured stroke.

Softhair Brushes. Although bristle brushes do most of the work in oil painting, it's helpful to have some softhair brushes for smoother, more precise brushwork. The top two brushes here are sables: a small, flat brush that makes smooth, rectangular strokes; and a round, pointed brush that makes fluent lines for sketching in the picture and adding linear details such as trickling foam or a crack in a rock. At the bottom is an oxhair brush, and just above it is a soft, white nylon brush; both make broad, smooth, squarish strokes.

Knives. A palette knife (top) is useful for mixing color on the palette, for scraping color off the palette at the end of a painting session, and for scraping color off the canvas when you're dissatisfied with what you've done and want to make a fresh start. A painting knife (bottom) has a very thick, flexible blade that's specially designed for spreading color on the canvas.

Brush Washer. To clean your brush as you paint, you rinse it in turpentine or mineral spirits (called white spirit in Britain). To create a convenient brush washer, save an empty food tin after you've removed the top; turn the tin over so the bottom faces up; then punch holes in the bottom with a pointed metal tool. Drop the tin into a wide-mouthed jar—with the perforated bottom of the tin facing up. Fill the jar with solvent. When you rinse your brush, the discarded paint sinks through the holes to the bottom of the jar; the solvent above the tin remains fairly clean.

Easel. For working indoors, a wooden studio easel is convenient. Your canvas board, stretched canvas, or gesso panel is held upright by wooden "grippers" that slide up and down to fit the size of the painting. They also adjust to match your own height. A studio easel should be the heaviest and sturdiest you can afford, so it won't wobble when you attack the painting with vigorous strokes. For working outdoors, you can get a wooden, lightweight, collapsible, tripod easel; to keep it steady in the wind some professionals sharpen the three legs and drive them into the ground.

Paintbox. A paintbox usually contains a wooden palette that you can lift out and hold as you paint. Beneath the palette, the lower half of the box contains compartments for tubes, brushes, knives, bottles of oil and turpentine, and other accessories. The lid of the paintbox often has grooves into which you can slide two or three canvas boards. The open lid will stand upright—with the help of a supporting metal strip which you see at the right—and can serve as an easel when you paint outdoors.

Palette. The wooden palette that comes inside your paintbox is the traditional mixing surface that artists have used for centuries. A convenient alternative is the paper tear-off palette: sheets of oilproof paper that are bound together like a sketchpad. You mix your colors on the top sheet, which you then tear off and discard at the end of the painting day, leaving a fresh sheet for the next painting session. This takes a lot less time than cleaning a wooden palette. Many artists also find it easier to mix colors on the white surface of the paper palette than on the brown surface of the wooden palette.

Palette Cups (Dippers). These two metal cups have gripping devices along the bottom so that you can clamp the cups over the edges of your palette. One cup is for turpentine or mineral spirits to thin your paint as you work. (Don't use this cup for rinsing your brush; that's what the brush washer is for.) The other cup is for your painting medium. This can be pure linseed oil; a 50-50 blend of linseed oil and turpentine that you mix yourself; or a painting medium that you buy in the art supply store—usually a blend of linseed oil, turpentine, and a resin such as damar, copal, or mastic.

Step 1. The tip of a round softhair brush draws the main shapes with tube color diluted with turpentine to the consistency of watercolor. (Even when the entire picture will be executed with bristle brushes, the round, softhair brush is the best tool for making the preliminary drawing.) The brush defines the horizon with a single line and then carefully defines the silhouettes of the three rocky shapes. The leaping foam also has a distinct shape—it's not just a blur—and this shape is defined as precisely as the rocks.

Step 2. A big bristle brush covers the sky with long, smooth strokes of tube color diluted with medium to a fluid consistency. Paler strokes suggest the horizontal movement of the clouds. Then a bristle brush picks up much thicker color—diluted with just a touch of painting medium—to cover the dark rocks with heavy strokes. The squarish strokes of the bristle brush redesign the rocks very slightly; they become more jagged and blocky. The weave of the canvas joins forces with the thickness of the paint to capture the rough texture of the rocks.

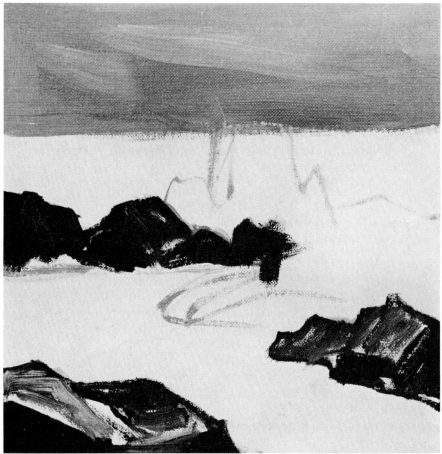

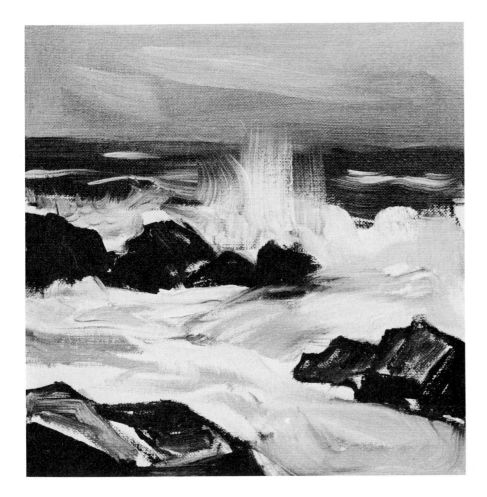

Step 3. A bristle brush covers the distant sea with dark, fluid strokes—the same consistency as the sky. Then a bristle brush picks up thicker color—diluted with painting medium to a creamy consistency—to paint the foamy surf. The movement of the brush follows the movement of the foam. The brush is pulled swiftly upward to render the flying foam behind the rocks. The foam flowing between the rocks is painted with big, curving strokes that follow the movement of the water. On the distant sea, a few horizontal strokes suggest foam on the tops of the waves.

Step 4. A bristle brush pulls the flying foam further upward across the distant sea and sky. Working with thick color, a smaller bristle brush adds detail to the flowing foam in the foreground. Strengthening the lights and the shadows. Pale, thick strokes complete the tops of the rocks, which now look rough, wet, and shiny. The entire picture retains the lively textures of bristle brushstrokes.

Step 1. The preliminary drawing is executed with the tip of a round softhair brush. The strokes of the softhair brush have a spontaneous, rhythmic character that captures the gentle curves of the waves at the horizon, as well as the more erratic curves of the crashing waves in the foreground. Always be sure to add enough turpentine to make the paint very fluid so that the softhair brush glides swiftly and effortlessly over the canvas.

Step 2. The first broad tones are applied with a long, springy, bristle brush—such as a filbert—which captures the lively movement of the distant waves beneath the horizon, then adds the darks that appear beneath the foam on the wave in the middleground. Quick movements of the bristle brush begin to add shadowy patches on the wave in the foreground.

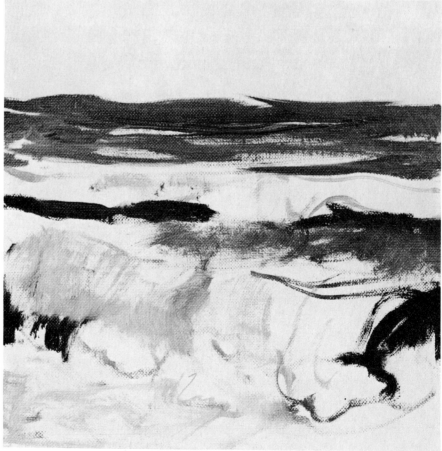

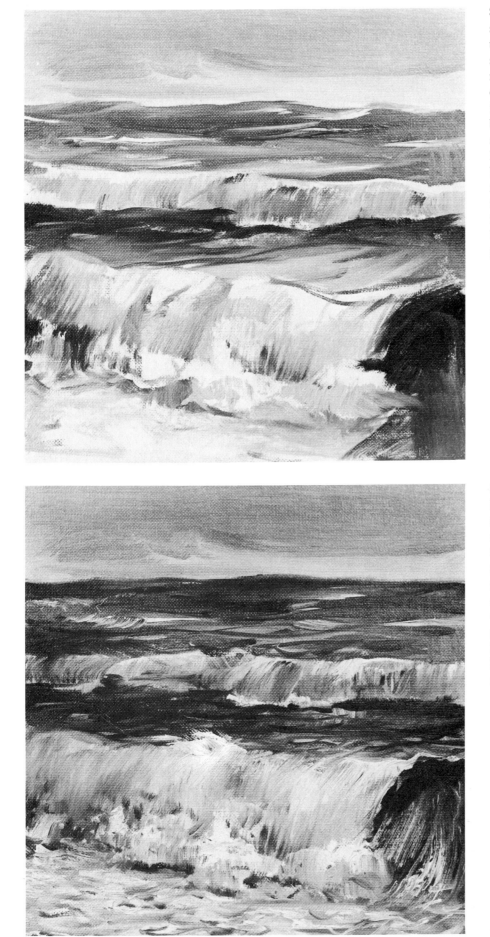

Step 3. A big bristle brush carries smooth strokes across the sky. Then the short, stiff bristles of a bright suggest the tones and textures of the rolling surf. Notice how the marks of the bristle brush capture the curving movement of the wave. The bright also darkens the shadowy inside of the wave at the lower right. Now the tip of a round softhair brush begins to add streaky, horizontal strokes to define the shining, foamy tops of the waves beneath the horizon, plus the dark ripples beneath the waves in the middleground.

Step 4. The stiff bristles of the bright complete the rolling surf with short, curving strokes of thick color. The tip of the round softhair brush completes the dark, distant sea and the dark strips of sea between the waves, with slender strokes that suggest ripples and low waves. In the immediate foreground, the round brush renders the foam-covered water with short, arc-like strokes that capture the movement of the ripples.

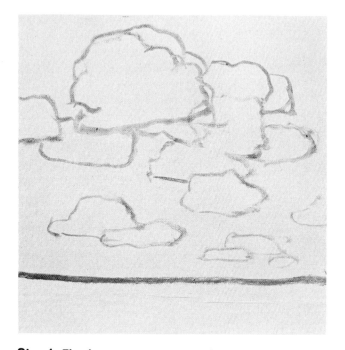

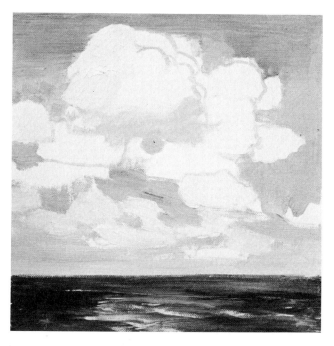

Step 1. Clouds may *seem* no more substantial than a puff of smoke, but to the artist, they're as solid and three-dimensional as any rock. The preliminary brush drawing defines their shapes with great care. Notice that these clouds are rounded and dome-like at the top, but tend to be flat at the bottom.

Step 2. A bristle brush surrounds the clouds with the tones of the sky. Here and there, these tones appear *between* the clouds. The first soft shadow tone is brushed along the bottom of the biggest cloud. The strip of sea is first covered with dark strokes, and then a round, softhair brush adds slender strokes to suggest light shining on the water.

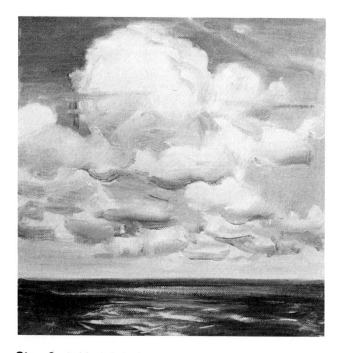

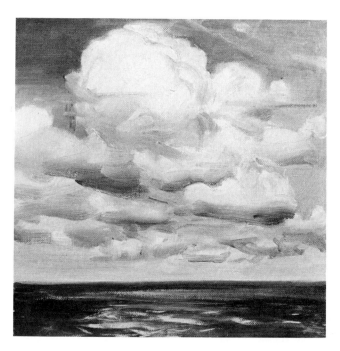

Step 3. A big bristle brush covers the sunlit tops of the clouds with thick, creamy color applied in curving strokes. The shadowy undersides of the clouds are painted with horizontal strokes of darker, more fluid color, which is blended softly into the paler tones above. The upper sky is darkened at the left, while a few wispy clouds are added at the upper right.

Step 4. Now some really strong shadows are added to the undersides of just a few clouds. The large bristle brush also simplifies the cloud formations by merging several smaller clouds into a few big shapes at the extreme left, and then enlarges the cloud at the lower right. The cloud formation has a distinct pattern of lights, darks, and middletones.

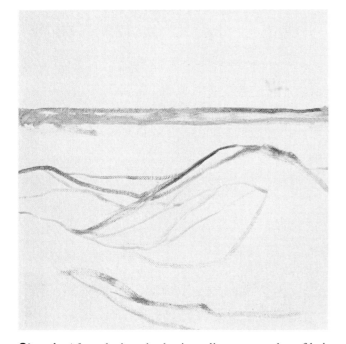

Step 1. After placing the horizon line, a round, softhair brush traces the curves of the dunes. Then, within the shape of the bigger dune, the brush draws the shapes of the shadows. Another shadow shape is indicated on the sand in the immediate foreground.

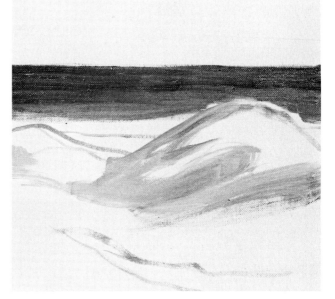

Step 2. A large bristle brush covers the distant sea with a dark tone that silhouettes the top of the bigger dune. Then a bristle brush moves down the sides of the dunes to indicate the shadows. Notice how the brushstrokes actually follow the sloping sides of the soft, round shapes.

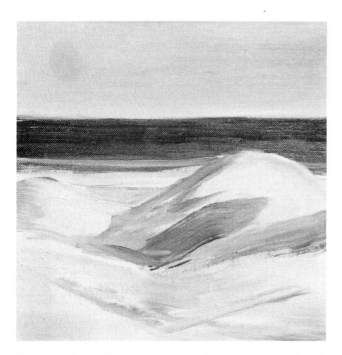

Step 3. The sunlit areas of the sand are now covered with smooth, creamy color, which is carried up to the edge of the beach. Delicate shadows are brushed across the foreground. Now each dune has a clearly defined light and shadow side. A pale tone is brushed across the sky.

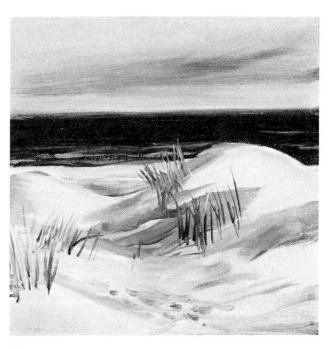

Step 4. Softhair brushes add touches of darkness to deepen the shadows, and then add beach grass among the dunes and a few pebbles in the foreground. The sea is darkened to emphasize the shape of the sunlit top of the big dune. A few lines of surf are added to the dark sea. The sky is completed with horizontal strokes that suggest cloud layers.

Step 1. As a general rule, most oil painters start with thin color, gradually working with thicker color as the painting progresses, saving their thickest strokes for the final stages. This study of a rock formation begins with a brush drawing in which the color is diluted with so much turpentine that the paint handles like watercolor. After the outlines of the rocks, sea, and tidepool are completed with a round softhair brush, a bristle brush covers the sky and sea with washes of liquid color—a little tube color and lots of turpentine. The tip of the round brush suggests shadows on the rocks with parallel strokes.

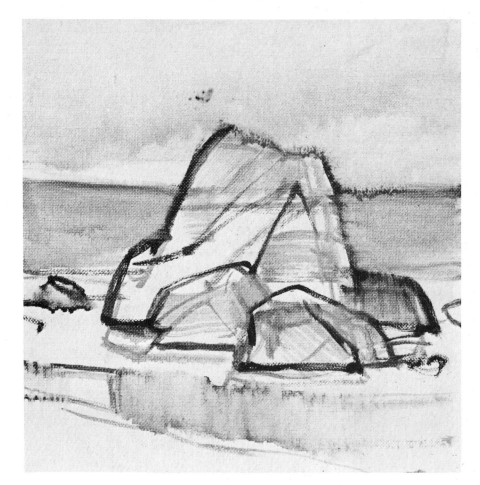

Step 2. Still working with liquid, transparent color—tube color and lots of turpentine—the round, soft-hair brush covers the rock formation with parallel strokes to indicate the pattern of lights, darks, and middletones. The lights are bare canvas, untouched by the brush. Some of these liquid tones are carried down into the tidepool to suggest reflections.

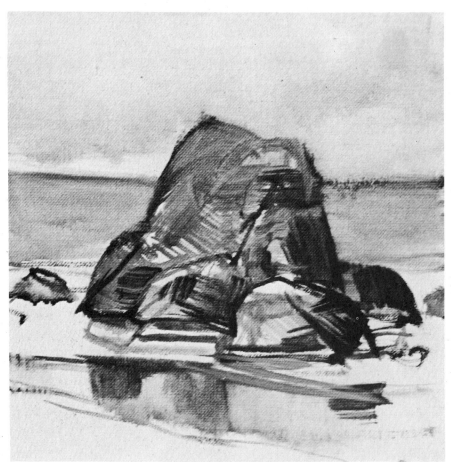

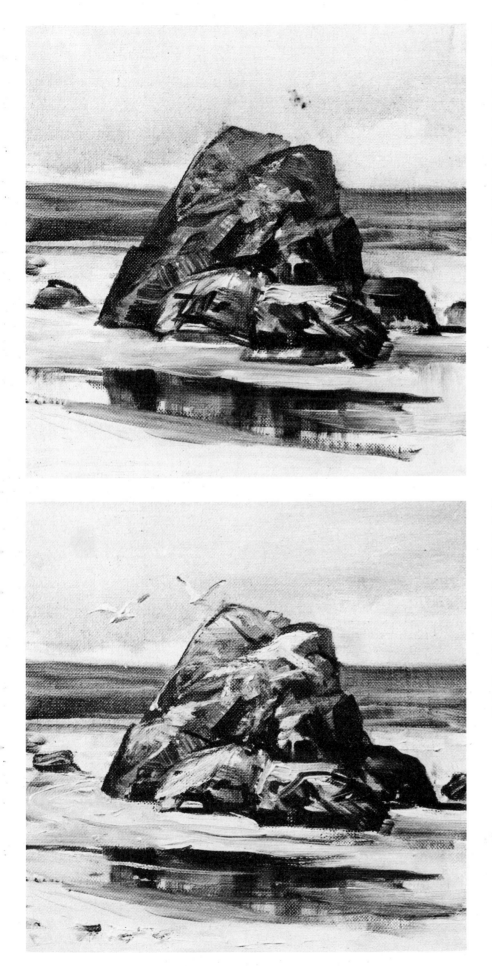

Step 3. The middletones and shadows are now strengthened with slightly thicker strokes of tube color diluted with painting medium to a smooth consistency something like thin cream. The underlying drawing in "turpentine washes" begins to disappear under strokes of more solid color. The sea and the tidepool are also strengthened with strokes of creamy color. The sandy beach is covered with horizontal strokes of tube color diluted with painting medium.

Step 4. Now the sunlit top planes of the rocks are completed with thick, richly textured strokes of tube color containing only a touch of painting medium. The sunlit sand is painted with thick strokes too. The gradual buildup from thin to thick gives you maximum control over the painting, since thin color is easier to handle than thick color. The last strokes of thick color have maximum impact because they're saved for the very end—and applied in just a few places.

Buying Brushes. There are three rules for buying brushes. First, buy the best you can afford—even if you can afford only a few. Second, buy big brushes, not little ones; big brushes encourage you to work in bold strokes. Third, buy brushes in pairs, roughly the same size. For example, if you're painting a sky, you can probably use one big brush for the patches of blue and the gray shadows on the clouds, but you'll want another brush, unsullied by blue or gray, to paint the white areas of the clouds.

Recommended Brushes. Begin with a couple of really big bristle brushes, around 1″ (25 mm) wide for painting your largest color areas. You might want to try two different shapes: one can be a flat, while the other might be a filbert. And one might be just a bit smaller than the other. The numbering systems of manufacturers vary, but you'll probably come reasonably close if you buy a number 12 and number 11. Then you'll need two or three bristle brushes about half this size, numbers 7 and 8 in the catalogs of most brush manufacturers. Again, try a flat, a filbert, and perhaps a bright. For painting smoother passages, details, and lines, three softhair brushes are useful: one that's about 1/2″ (13 mm) wide; one that's about half this wide; and a pointed, round brush that's about 1/8″ or 3/16″ (3-5 mm) thick at the widest point.

Knives. For mixing colors on the palette and for scraping a wet canvas when you want to make a correction, a palette knife is essential. Many oil painters prefer to mix colors with a knife. If you'd like to *paint* with a knife, don't use the palette knife. Instead, buy a painting knife, with a short, flexible, diamond-shaped blade.

Painting Surfaces. When you're starting to paint in oil, you can buy inexpensive canvas boards at any art supply store. These are made of canvas coated with white paint and glued to sturdy cardboard in standard sizes that will fit into your paintbox. Later, you can buy stretched canvas—sheets of canvas precoated with white paint and nailed to a rectangular frame made of wooden stretcher bars. You can save money by stretching your own canvas. You buy the stretcher bars and canvas and then assemble them yourself. If you like to paint on a smooth surface, buy sheets of hardboard and coat them with acrylic gesso, a thick, white paint that you buy in cans or jars and then thin with water.

Easel. An easel is helpful, but not essential. It's just a wooden framework with two "grippers" that hold the canvas upright while you paint. The "grippers" slide up and down to fit larger or smaller paintings—and to match your height. If you'd rather not invest in an easel, there's nothing wrong with hammering a few nails partway into the wall and resting your painting on them; if the heads of the nails overlap the edges of the painting, they'll hold it securely. Most paintboxes have lids with grooves to hold canvas boards. When you flip the lid upright, the lid becomes your easel.

Paintbox. To store your painting equipment and to carry your gear outdoors, a wooden paintbox is a great convenience. The box has compartments for brushes, knives, tubes, small bottles of oil and turpentine, and other accessories. It usually holds a palette—plus some canvas boards inside the lid.

Palette. A wooden paintbox often comes with a wooden palette. Rub the palette with several coats of linseed oil to make the surface smooth, shiny, and nonabsorbent. When the oil is dry, the palette won't soak up your tube colors, and the surface will be easy to clean at the end of the painting day. Even more convenient is a paper palette. This looks like a sketchpad, but the pages are nonabsorbent paper. At the beginning of the painting day, you squeeze out your colors on the top sheet. When you're finished, you just tear off and discard the top sheet. Paper palettes come in standard sizes that fit into paintboxes.

Odds and Ends. To hold your turpentine and your painting medium—which might be plain linseed oil or one of the mixtures you read about earlier—buy two metal palette cups (or "dippers"). To sketch the composition on your canvas before you start to paint, buy a few sticks of natural charcoal—not charcoal pencils or compressed charcoal. Keep a clean rag handy to dust off the charcoal and make the lines paler before you start to paint. Some smooth, absorbent, lint-free rags are good for wiping mistakes off your painting surface. Paper towels or a stack of old newspapers (a lot cheaper than paper towels) are essential for wiping your brush when you've rinsed it in turpentine. For stretching your own canvas, buy a hammer (preferably with a magnetic head), some nails or carpet tacks about 3/8″ (9-10 mm) long, scissors, and a ruler.

Work Layout. Before you start to paint, lay out your equipment in a consistent way so that everything is always in its place when you reach for it. If you're right-handed, place the palette on a tabletop to your right, along with a jar of turpentine, your rags and newspapers or paper towels, and clean jar in which you store your brushes, hair end up. Establish a fixed location for each color on your palette. One good way is to place your *cool* colors (black, blue, green) along one edge and the *warm* colors (yellow, orange, red, brown) along another edge. Put a big dab of white in one corner, so it won't be fouled by the other colors.

Waves on Sunny Day. A sunny day means a bright blue sky. Since the color of the water normally reflects the color of the sky, a blue sky means blue water—or blue-green. Notice that these waves aren't a uniform, monotonous blue, but contain hints of other colors. The warm, pale sky tone, just above the horizon, reappears in the pale strokes that suggest the sunlight shining on the waves.

Waves on Overcast Day. When the colors of the sky are more subdued, the waves also darken. However, an overcast day doesn't necessarily mean a uniformly gray sky. This sky is actually full of color—blue-grays and brown-grays—and darker versions of these same colors appear in the sea.

Surf on Sunny Day. Under a bright blue sky, the surf tends to have a warm, sunny tone. The sunlit tops of these crashing waves aren't pure white, but pick up the warm tone of the sun. The shadowy face of the crashing wave contains warm grays and hints of tan or gold.

Surf on Overcast Day. Even when the sun is blocked by an overcast sky, the crashing surf has a lighted top and a shadowy face. The top isn't pure white, but contains a hint of gray. The shadowy face of the crashing wave is predominantly gray, but contains suggestions of blue, plus some warm tones that reflect the distant sun and the colors of the beach.

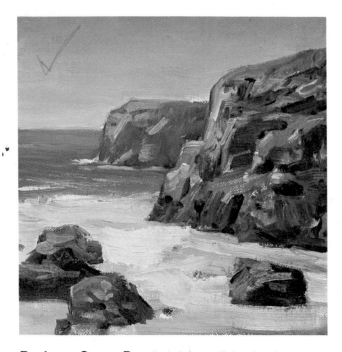

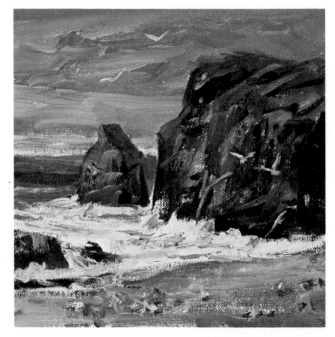

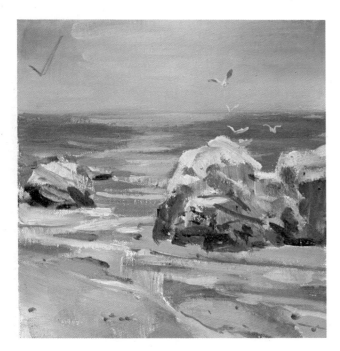

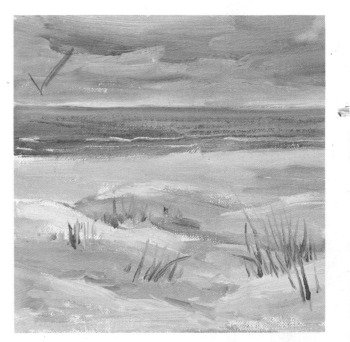

Rocks on Sunny Day. In bright sunlight, there's a strong contrast between the lighted top planes of the rocks and the dark, shadowy sides. The lighted tops are warmed by the sun, while the sides often contain a hint of cool color, reflecting the tone of the sky. This is equally true of the rocks on the beach and the massive headlands—which are just bigger rocks.

Rocks on Overcast Day. When the sky turns gray and there's less direct sunshine, you may find very little contrast between the colors of the top and side planes of rocks and headlands. The rock formations turn dark overall, and the shadows are only a bit darker. Here and there, the tops pick up a hint of the paler tone of the sky.

Beach on Sunny Day. When the sun shines brightly on the beach, the sand is a pale tan, with an occasional hint of gold. You can exaggerate the golden tone in a few places— as you see here—but don't overdo it. Sunlit sand is basically tan, with cool shadows that reflect the tone of the sky.

Beach on Overcast Day. When the sun is screened by clouds, the color of the sand turns distinctly cooler. It tends to be a grayish tan or a bluish gray. The shadows still reflect the color of the sky. You sometimes find a hint of warm color in the shadows, which you can exaggerate just a bit.

Clear Sky. A cloudless, sunny sky is usually darkest and bluest at the zenith, growing paler and warmer toward the horizon. The same thing happens to the reflective surface of the sea, which looks darkest and bluest at the horizon, gradually growing paler and warmer toward the shore.

Overcast Sky. A ''gray'' sky can be much more dramatic than you might expect. Here, the dark clouds are concentrated at the horizon, allowing some gentle rays of sunlight to break through at the top. This subdued sunlight is reflected by the surface of the sea, which contrasts beautifully with the cloud layer above. Notice that the sunlight isn't a bright yellow, but a very muted gold-gray.

Sunset. The colors of the sunset aren't nearly as fiery as most beginners paint them. The brightest, warmest colors are usually at the horizon, while the upper sky is more subdued. The clouds are darker and even more subdued than the sky, picking up hints of bright sunlight along their lower edges. As usual, the sea mirrors the sky—brightest at the horizon and more subdued in the foreground.

Stormy Sky. The dark, ominous tones of a stormy sky contain more color than you might expect. These clouds contain blues, blue-grays, brown-grays, and subdued golden tones where the sunlight breaks through the clouds. The reflecting surfaces of the waves carry brighter versions of the same colors.

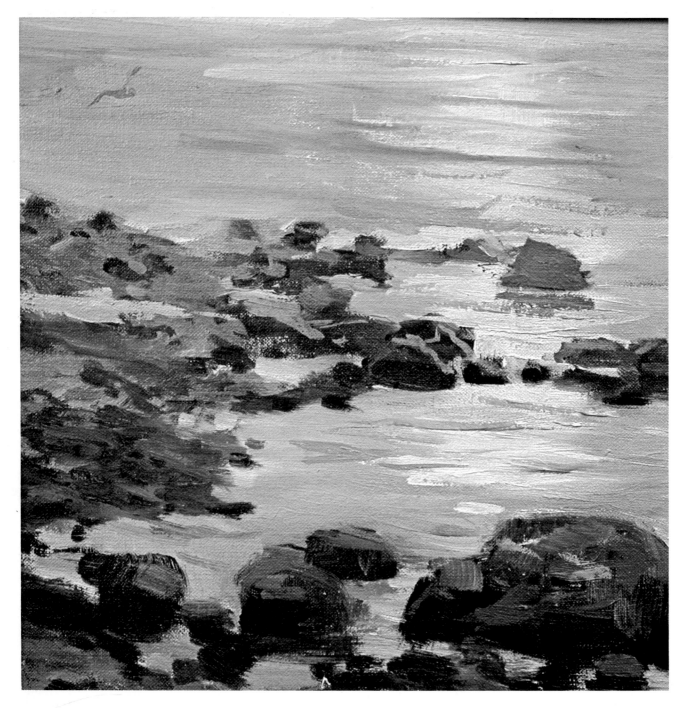

Thick Color. Remember that you can plan the *consistency* of your paint to match the character of the subject. For thick strokes, you can work with pure tube color or just add the slightest touch of painting medium to make the color "brush out" more easily. For more fluid strokes, you can add more painting medium, while a bit of turpentine will make the color even more fluid. In this close-up from a much larger painting of a rocky shoreline, the dark tones of the water, as well as the rocks and seaweed in the middle distance, are painted with smooth, creamy color diluted with a fair amount of painting medium. The foreground rocks are painted with strokes of thicker color, containing less medium, to emphasize the rocky texture. And the brilliant sunlight, shining on the sea, is painted with horizontal strokes of thick, pasty color. Some of these sunny strokes are thick enough to stand up from the surface of the canvas. The brilliance of the sunlight is emphasized by the thickness of the paint.

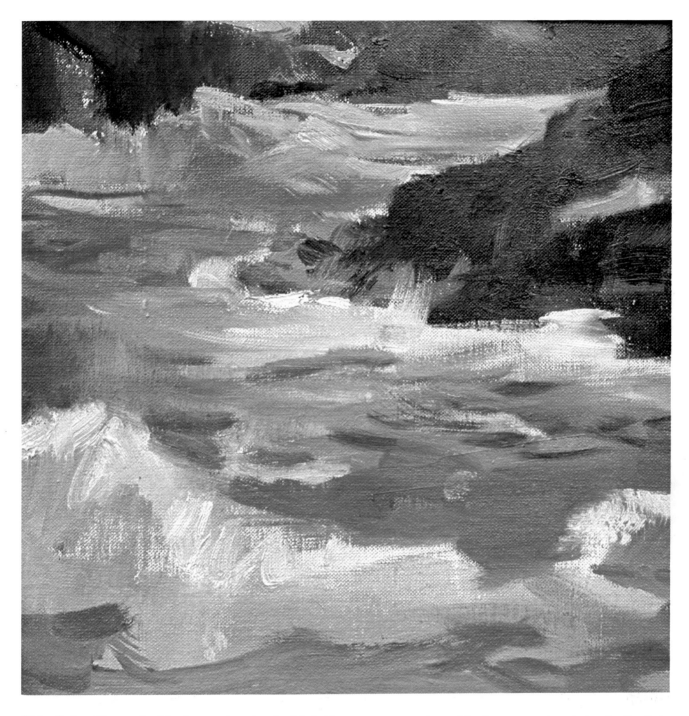

Thin Color. The sea in this close-up is painted with fluid color that contains a good deal of painting medium. Here, the goal is to capture the lively splash and flow of the water. The brush moves quickly over the canvas, following the movement of the waves. It's important for the color to contain plenty of medium so the brush can move rapidly and spontaneously, making long, sweeping strokes for the flowing water; short, choppy strokes for the ripples; and quick, upward scrubs for the splashing foam. In the foreground, you can see that the paint is actually thin enough to reveal the weave of the canvas. In the lower left, strokes of thicker color emphasize the sunlit top of the foam.

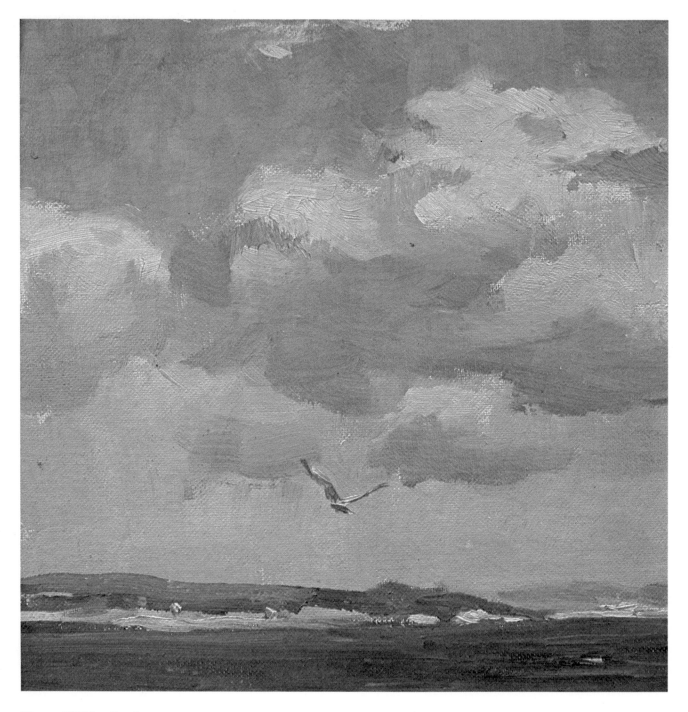

Warm Within Cool. Seascapes and coastal landscapes contain so much sea and sky that the picture is often dominated by cool colors—blues, greens, blue-greens, blue-grays, and green-grays. When your color scheme is basically cool, it's important to look for some notes of warm color that will contrast with the cool, and give the viewer a pleasant change of pace. These warm colors don't have to be hot reds, oranges, and yellows; they might also be sub-dued browns, brownish-grays, tans, pinks, or violets. Notice how these delicate, warm tones are softly brushed into the cool colors of the sky. If you can't actually *find* the warm tones you need, there's nothing wrong with inventing them—just keep them quiet. Remember that this strategy is just as important when you're painting a predominantly warm picture, such as a sandy beach: try to introduce a few cool colors for relief.

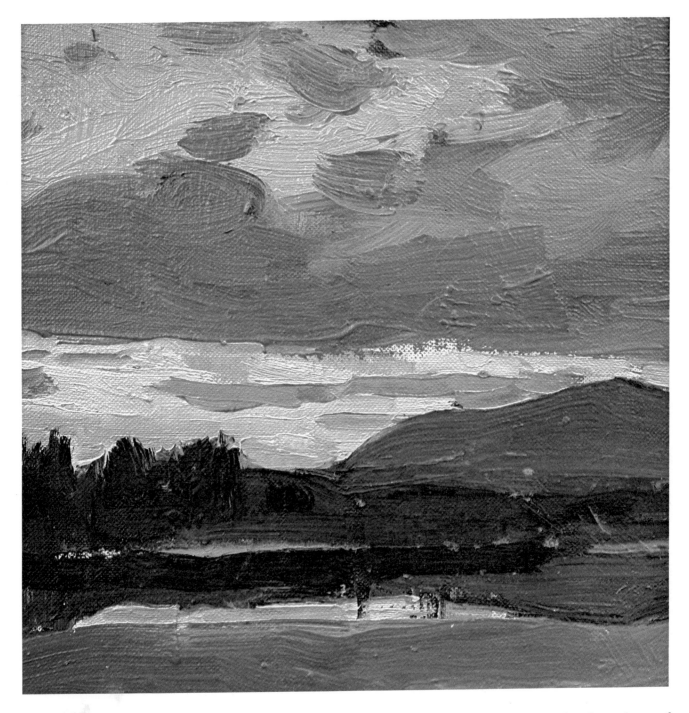

Warm Against Cool. You've seen that one method of introducing warm color is to blend a few warm notes into the cool tones with subtle strokes. Another method is to design your picture so that the composition contains alternating areas of cool and warm color. In this close-up taken from a much larger picture, there's a patch of warm color at the very top of the sky, followed by the cool tone of the clouds, which contrasts beautifully with the warm strip of sunlit sky just above the horizon. The rest of the picture is literally di- vided into bands of cool and warm color: the cool tone of the hills; the warm tone at the foot of the hills; the cool tone of the grassy shore and the clump of trees; and the various strips of warm and cool color that are reflected in the water. Before you start to paint, it's a good idea to decide which way your picture will go: predominantly cool, with some notes of warm color; or predominantly warm, with some notes of cool color. This is a cool picture with warm notes.

Step 1. A round softhair brush draws the major shapes of the composition with cobalt blue diluted with turpentine to a liquid consistency. Although the soft forms of the clouds are constantly changing, it's important to focus your attention on the sky, make a firm decision about where you want the clouds to be, and record the shapes of the cloud mass and the patches of open sky with the minimum number of quick, decisive strokes. In the same way, watch the repetitive action of the waves and then freeze each wave in your mind, drawing its curving edge and the shape of the foam with a few firm strokes.

Step 2. A big bristle brush paints the distant water with long, horizontal strokes of cobalt blue, yellow ochre, viridian, and white, diluted with painting medium to a creamy consistency. Notice that some strokes are darker and cooler, containing more cobalt blue, while other strokes are paler and warmer, containing more yellow ochre. (At the center of the distant sea, some patches of canvas are left bare to suggest the reflection of the sunlight on the water.) A single stroke of this same mixture, darkened with more cobalt blue, suggests the shadow in the curl of one wave.

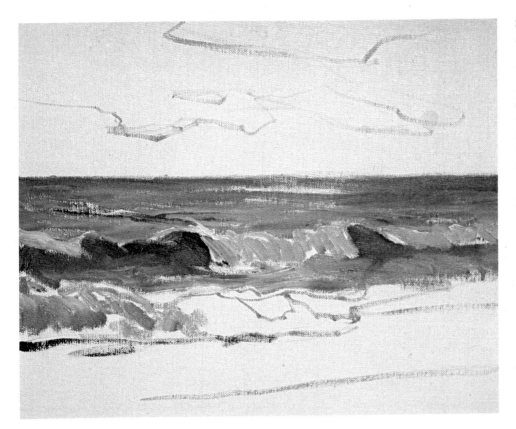

Step 3. The face of the wave curves over and is therefore in shadow— painted with cobalt blue, viridian, yellow ochre, and white. The strokes are darker at the upper edge, where the mixture contains more cobalt blue, and paler at the base of the wave, where the mixture contains more white. The shadowy foam is painted with broad, diagonal strokes of cobalt blue, yellow ochre, burnt umber, and lots of white. Work begins on the foreground wave with this same mixture with more cobalt blue and less white. At the right, a warm patch of water catches the sunlight; this is painted with the foam mixture, with more yellow ochre.

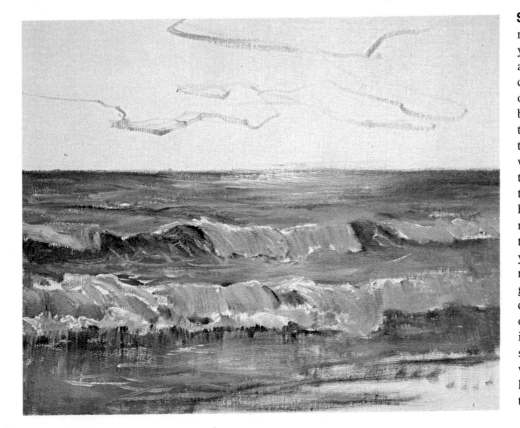

Step 4. Still working with a mixture of cobalt blue, yellow ochre, burnt umber, and white, a bristle brush completes the shadow tones on the surf. Notice how the brushstrokes curve downward to suggest the foam crashing toward the water. The strip of water between the waves, and the water that washes up on the beach, are covered with horizontal strokes of the same mixture used to paint the distant sea: cobalt blue, viridian, yellow ochre, and white. Beneath the edge of the foreground wave, the water is darkened with vertical strokes of this same mixture, containing more cobalt blue. A round softhair brush picks up pure white, tinted with a little yellow ochre, to trace the sunlit tops of the foamy shapes.

Step 5. A big bristle brush covers the lower sky with a mixture of cobalt blue, burnt umber, yellow ochre, and white—with some additional strokes of white where the sun's rays will appear at the center. The brush carries this mixture to the top of the canvas to suggest more patches of sky. More white is blended into this mixture, and a bristle brush carries horizontal strokes across the distant ocean to suggest the sun shining on the sea. The wet beach in the foreground is darkened with more strokes of the original mixture that appears in Step 4. Strokes of this mixture darken the waves in the foreground and are carried across the distant sea to suggest waves.

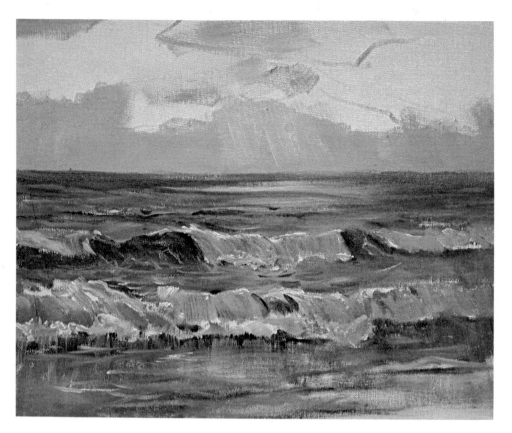

Step 6. The bold shapes of the clouds are painted with broad strokes of a big bristle brush that carries a darker mixture of cobalt blue, yellow ochre, burnt umber, and white. Then a smaller bristle brush traces the sunlit edges of the clouds with thick strokes of white tinted with yellow ochre. This same brush reinforces the rays of the sun that first appear in Step 5. The cloud mixture is brushed across the shiny beach in the foreground, covering the last patches of bare canvas. A round softhair brush adds two gulls above the horizon with a darker version of the cloud mixture and, with the dark tone of the water, begins to adds small, dark strokes to suggest ripples between the waves.

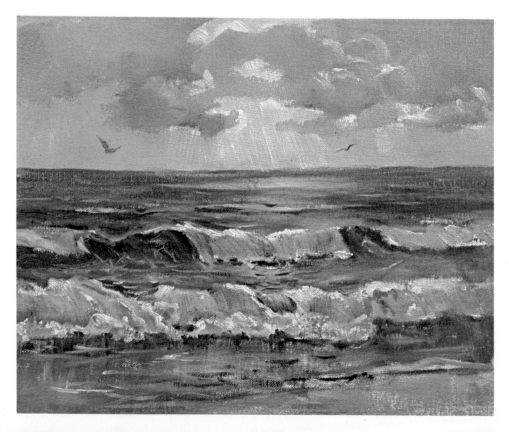

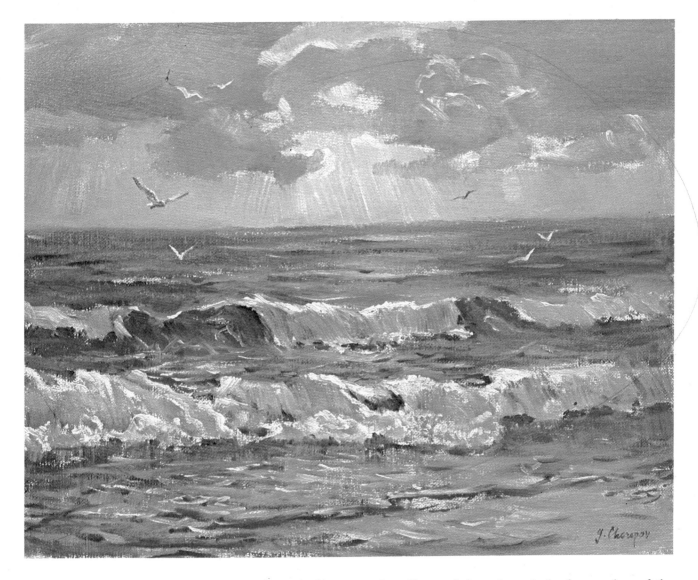

Step 7. A bristle brush blends more yellow ochre and white into the foreground to suggest the warm glow of the sun on the water—and perhaps the influence of the warm color of the underlying sand. The distant ocean is also warmed with some horizontal strokes of this mixture; now the water clearly reflects the warm tone of the sky. A big bristle brush darkens the cloud at the upper left to heighten the contrast between the shadowy cloud and the sunny sky beneath. The tip of a round softhair brush travels swiftly across the foreground and over the space between the waves, making small, arc-like strokes of white and yellow ochre to suggest the sun gleaming on the ripples. This same brush adds darker ripples with a mixture of cobalt blue and burnt umber. Here and there, beneath the foamy edges of the breaking waves, this brush adds a few dark strokes to create shadows and heighten the contrast between the pale foam and the darker water. The small brush adds touches of sunlight (white and yellow ochre) to the biggest gull at the left, then adds more gulls with this same mixture. The finished painting is a fascinating example of the interplay of sky and water. The waves do contain blue and green, of course, but these cool tones constantly interweave with the subtle, warm tones of the sun breaking through the overcast sky. The surf is essentially the same color as the clouds, both in the light and in the shadows. After all, surf, like clear water, is a reflecting surface.

Step 1. The big, rugged shapes of this dramatic seascape don't require a precise preliminary brush drawing, so the first lines on the canvas are executed with a small bristle brush rather than the usual softhair brush. Phthalocyanine blue is warmed with burnt umber and the mixture is then diluted with lots of turpentine. The small bristle brush indicates the horizon and the waves at the left with a few casual strokes. The shape of the surf is carefully defined. Then, working with darker color, the brush draws the silhouettes of the rocks and fills one tiny rock with solid color. This small rock is important because it balances the bigger shapes.

Step 2. Working with the original mixture of phthalocyanine blue and burnt umber, softened with white and diluted with turpentine *and* painting medium, a big bristle brush scrubs in the shadow tone of the surf. The up-and-down movement of the brush begins to suggest the upward splash of the foam.

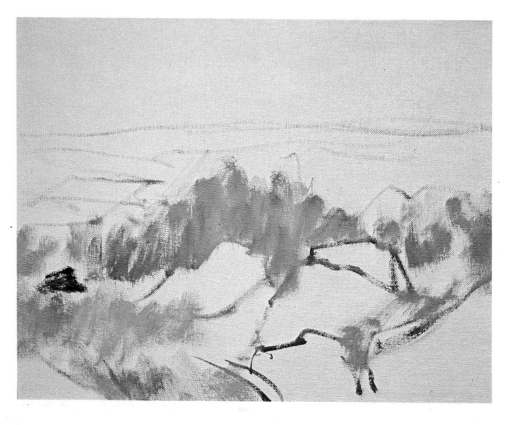

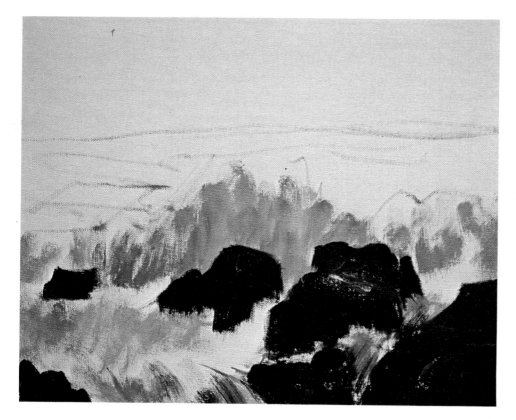

Step 3. The dark shapes of the rocks are covered with broad strokes of phthalocyanine blue and burnt sienna. The square end of a large bristle brush makes squarish strokes that accentuate the blocky forms of the rocks. At this stage, it's most important to establish the contrast of three tones: the dark rocks, the shadow plane of the foam, and the bare canvas that represents the lighted areas of the foam.

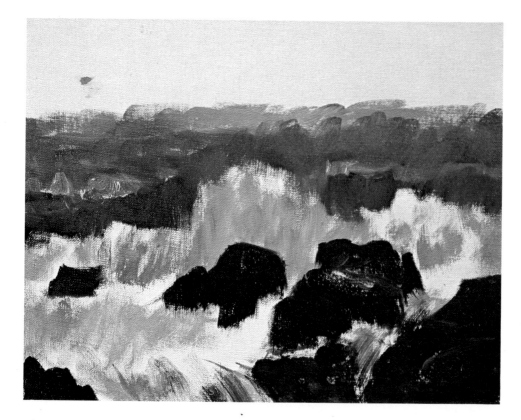

Step 4. The distant waves are painted with short, scrubby strokes of phthalocyanine blue, burnt sienna, and white. Notice that some strokes contain more white, while others contain more phthalocyanine blue or burnt sienna. The strokes are darkest directly behind the foam and lightest at the horizon. Now the sunlit edge of the surf is clearly silhouetted against the dark, distant waves. These lighted areas are still bare canvas.

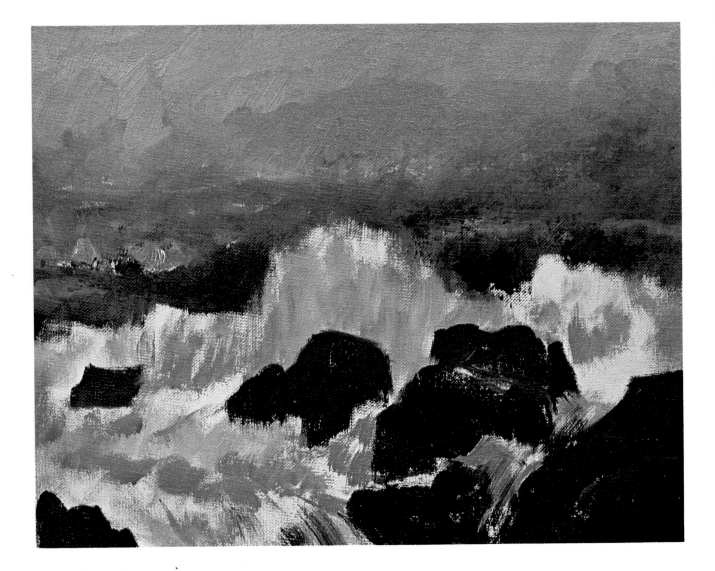

Step 5. The sky is covered with irregular strokes of phthalocyanine blue, burnt sienna, and white, diluted with painting medium to a more fluid consistency than the waves beneath. The sky mixture contains more burnt sienna and white than the mixture used to paint the waves. A big bristle brush carries the sky tone downward over the sea, blending the two tones together. The distant waves are now paler and more remote; the horizon seems to melt away into the sky. Directly behind the surf, a bristle brush adds some dark touches of the rock mixture to heighten the contrast between the pale tone of the surf and the dark waves. In the left foreground, a bristle brush adds shadows to the surf with the sky mixture. A few strokes of the sky mixture are carried over the rocks to make them look wet. It's interesting to see how *little* detail the painting contains even at this late stage. The emphasis is on big shapes and broad tones. When these are right, the picture is close to completion.

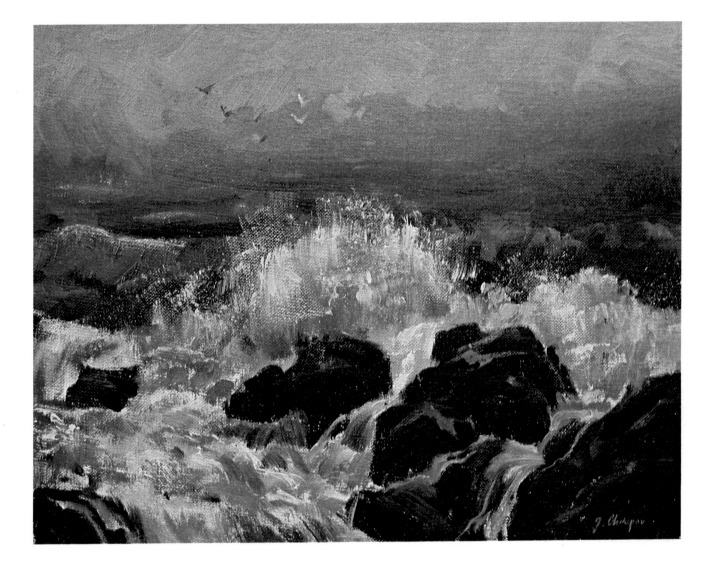

Step 6. Now smaller bristle brushes go back to work on the rocks in order to divide those dark shapes into top and side planes. Warm strokes of phthalocyanine blue, burnt sienna, yellow ochre, and white—obviously dominated by the burnt sienna—are carried across the tops of the rocks. A darker version of this mixture, containing less white and more phthalocyanine blue, is carried down the sides of the rocks. Now the rocks look warmer and more three-dimensional. The tip of a small bristle brush makes the rocks look wet by adding some slender strokes of the sky mixture—phthalocyanine blue, burnt sienna, and lots of white. Thick white, straight from the tube, is tinted with this mixture and just a little painting medium is added to produce a dense, creamy consistency. Then a bristle brush travels over the foam, adding thick touches of this cool white to cover the bare canvas that represented the sunlit foam in Step 5. The brush is then pulled upward with short, quick strokes that suggest the flying foam behind the rocks. In the left foreground, the strokes curve downward from left to right, following the action of the foam flowing over the rocks. The shadow tones within the surf are darkened with fluid strokes of the sky mixture; these tones are most apparent directly behind the rocks and in the middle of the foreground, where the foam pours over the rocks. A large bristle brush darkens the lower sky and blends the meeting place of sea and sky into one continuous, dark tone. Behind the exploding surf, a small bristle brush adds a few pale strokes to suggest the foamy tops of more distant waves. The tip of a round brush adds some gulls. Except for these gulls, the entire picture is painted with stiff bristle brushes whose rough strokes match the texture and the action of the subject.

Step 1. One of the most beautiful seaside subjects is the pattern of tidepools and sandbars created by receding water. These shapes form a fascinating and intricate design which you must draw carefully—in contrast with the more casual drawing in Demonstration 2. A round softhair brush traces the shapes of the clouds, the horizon line, the band of light just below the horizon, the sandbar, the tidepools, the edge of the beach, and the shoreline rocks. The brush works with the basic palette that will be used throughout the painting: cobalt blue, alizarin crimson, yellow ochre, and white, thinned with lots of turpentine.

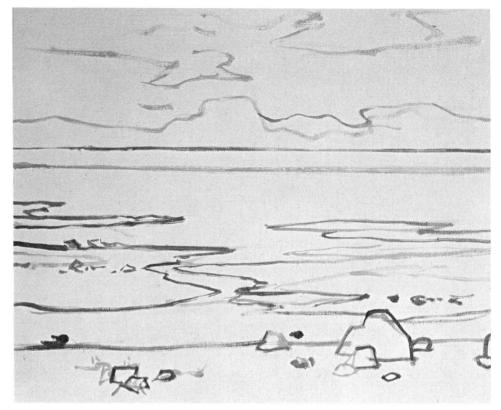

Step 2. A large bristle brush covers the patches of sunlit sky appearing between the clouds and the reflecting surface of the water. The strokes are all various mixtures of cobalt blue, alizarin crimson, yellow ochre, and white. The lightest, brightest areas obviously contain more yellow ochre and white, while the darker tones contain more cobalt blue and alizarin crimson. Because the shapes in the original drawing are so important, these big strokes are painted carefully to avoid obliterating the lines.

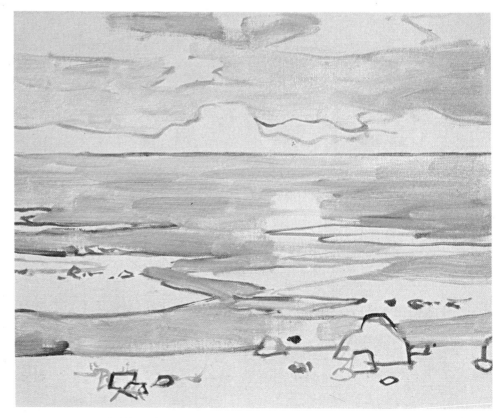

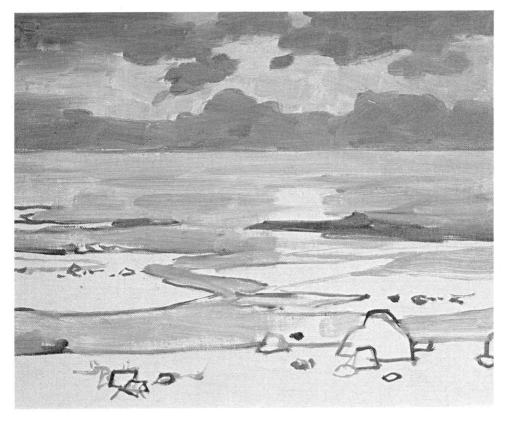

Step 3. Following the original brush drawing as carefully as possible, a bristle brush blocks in the dark clouds. This is still the basic combination of cobalt blue, alizarin crimson, yellow ochre, and white, but the clouds obviously contain less white than the sunlit sky—the clouds are dominated by cobalt blue and alizarin crimson. Adding more alizarin crimson and yellow ochre to this mixture, a small bristle brush begins to paint the outlying sandbars.

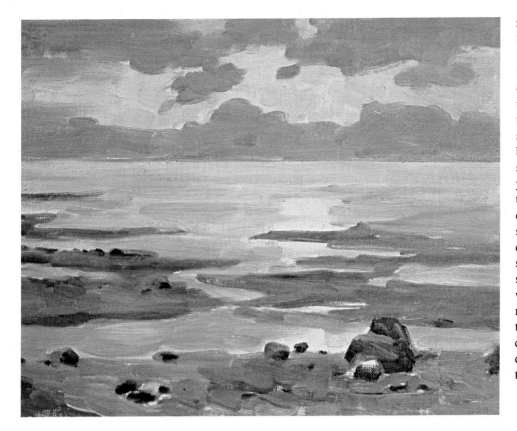

Step 4. The small bristle brush continues to cover the sandbars with this mixture, which contains more alizarin crimson and yellow ochre than the clouds. The colors of the strokes vary, the cooler strokes containing more cobalt blue and the warmer strokes containing more yellow ochre. The beach in the immediate foreground is covered with thick, short strokes of this mixture. More cobalt blue and alizarin crimson are added to paint the shadow sides of the rocks, while the lighted tops of the rocks are the same mixture as the sandbars. Notice how the closest tidepool has been darkened to reflect the cloud tone.

Step 5. A bristle brush brightens the center of the sky with more yellow ochre and white, then blends alizarin crimson, yellow ochre, and white into the lower edge of the sky and the surrounding clouds. Thick, horizontal strokes of white and yellow ochre are carried down over the water to create the bright reflection of the sun. Strokes of the cloud mixture are blended into the water as it approaches the shore. The edges of the sandbars are also modified with strokes of this mixture. A round softhair brush adds dark touches to suggest more pebbles, then brightens the tops of the pebbles with the sky tone. A single dark stroke suggests a strip of distant shore.

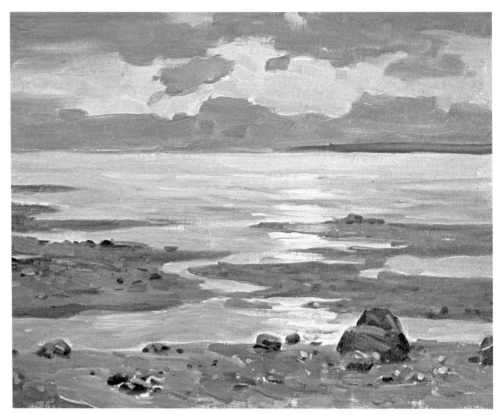

Step 6. The clouds are warmed and darkened with strokes of the original mixture modified with more alizarin crimson and yellow ochre. Then the edges of the clouds are brightened with thick strokes of yellow ochre and white. Now there's a much stronger contrast between the dark clouds and the glowing sky. On either side of the reflection of the sun on the water, the sea is darkened very slightly by blending in some soft strokes of the cloud mixture. This brightens the reflection. The sandbars are also darkened and warmed with a version of the original mixture that contains more yellow ochre and less white. Now there's a much stronger contrast between the sandbars and the tide pools.

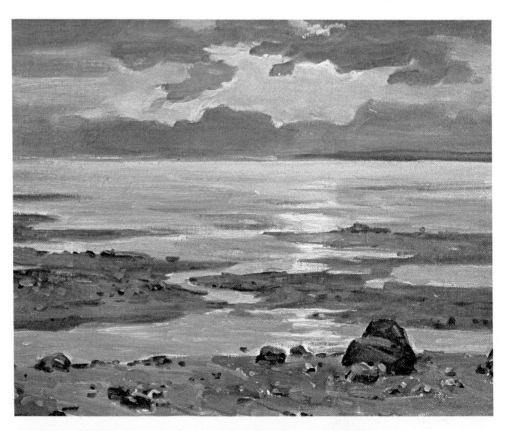

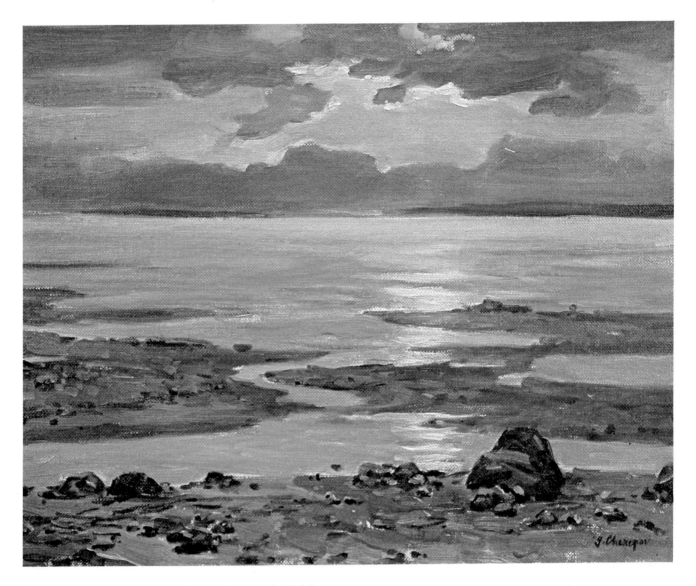

Step 7. To focus the viewer's attention on the brightest patch of sky and the reflection on the water beneath, the sea and the sandbars are darkened still more. On either side of the sun's reflection in the ocean, a bristle brush softly blends horizontal strokes of the cloud mixture into the water. The reflection and the sunlit clouds above are brightened with thick strokes of yellow ochre and white. Strokes of the darkest cloud mixture are carried over the sandbars and the beach. Notice how the water is palest at the horizon and gradually grows darker until it reaches the edge of the beach. In the same way, the distant sandbars are palest and the beach in the immediate foreground is darkest. Now the interlocking shapes of the dark sandbars and the paler water form a beautiful, jagged pattern. This contrast is echoed by the sky in which the dark clouds seem to float like islands in a sea of sunlight. The tip of a round, softhair brush adds the last few rocks and pebbles with the mixture that first appeared in Step 4. Here and there, the foreground is brightened with a few casual strokes of burnt sienna and cadmium yellow to suggest the warm tones of seaweed scattered on the beach.

Step 1. When the sea invades the land, and "islands" of marsh grass spring up out of the salt water, this is called a salt marsh. The round, soft-hair brush draws just a few preliminary lines in burnt umber and yellow ochre diluted with plenty of turpentine, plus the horizon line, the shapes of a few clouds, a strip of land at the horizon, and a few scribbly strokes to suggest the marsh grass in the foreground and the middleground. Then the golden tones of the early evening sky are begun with a few broad strokes of yellow ochre and white, placed above the horizon with a bristle brush. The dark strip of coastline is painted with a mixture of cobalt blue, yellow ochre, burnt umber, and white.

Step 2. The slightly darker patches of sky at the top of the canvas are painted with a big bristle brush that carries the same mixture of yellow ochre and white that appears in Step 1, but here darkened very slightly with cobalt blue and burnt umber. Then the dark shape of the cloud is carried over the sky tone with cobalt blue, yellow ochre, a touch of alizarin crimson, and white. So far, the paint is thinned with lots of painting medium to a consistency something like thin cream. At the upper right, notice how the dark patch of sky is blended softly into the paler, brighter sky tone below.

Step 3. For the darker clouds, cobalt blue, yellow ochre, alizarin crimson, and white are blended on the palette—but now the mixture contains more yellow ochre and alizarin crimson than the cloud in Step 2. A large bristle brush carries this mixture over the center of the sky and up to the top to create a darker, warmer cloud. A wisp of this cloud mixture is placed in the upper left corner. A paler stroke of this mixture suggests a cloud layer just above the horizon at the right. Just above this warm cloud layer, a cooler cloud is painted with the same mixture that appears in Step 2. The dark shoreline is reshaped as the clouds are painted. A reflection of the cloud mixture is placed in the water.

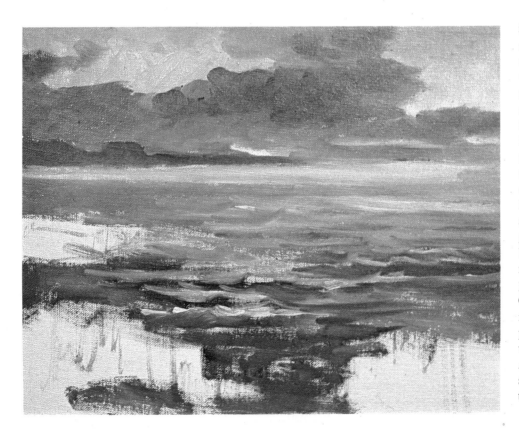

Step 4. A bristle brush carries the sky colors down into the water. At the horizon, the water begins with horizontal strokes of the warm, pale sky mixture. Working toward the foreground, the brush adds horizontal strokes of cloud tone, then interrupts these with ripples that reflect the color of the pale sky. Notice how the water grows darker as it approaches the foreground—containing more cobalt blue in some strokes, more alizarin crimson and yellow ochre in other strokes. Closer to the foreground, the ripples grow brighter; they're painted with almost pure white, tinted with sky tone. At this stage, the colors of the sky are repeated throughout the water.

Step 5. Work continues on the water in the foreground, which is covered with more of the dark cloud color. More cobalt blue is added to this mixture for the dark ripples, while the sunstruck ripples are painted with pure white, sometimes tinted with the warm sky color and sometimes tinted with the cool cloud mixture. These ripples are painted with the tip of a round softhair brush. This same brush is rinsed and begins to paint the marsh grass with rapid, slender strokes. The blades of grass are painted with various mixtures of viridian, burnt sienna, yellow ochre, and white; the dark strokes contain more viridian, while the warmer strokes contain more burnt sienna.

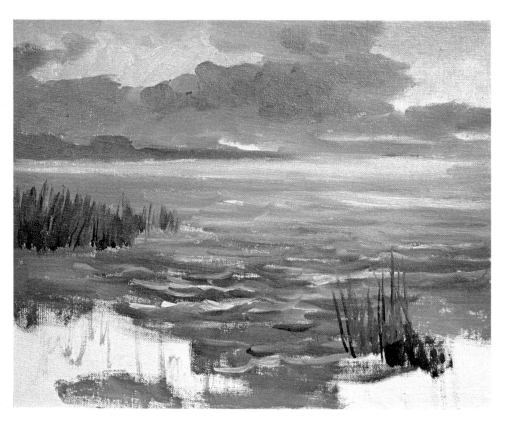

Step 6. In the lower right and left corners, the canvas is covered with strokes of marsh grass. The round softhair brush continues to work with viridian, burnt umber, yellow ochre, and white. Then, for the darker strokes, ultramarine blue is substituted for viridian. To suggest a few blades of grass caught in sunlight, the brush works with *almost* pure white, tinted with a little yellow ochre and viridian. A bristle brush carries the dark tones of the foreground water among the marsh grass. Then the round brush returns to add more sunlit ripples with strokes of thick white tinted with yellow ochre.

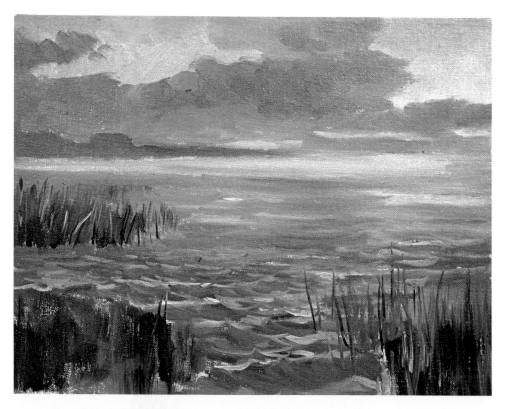

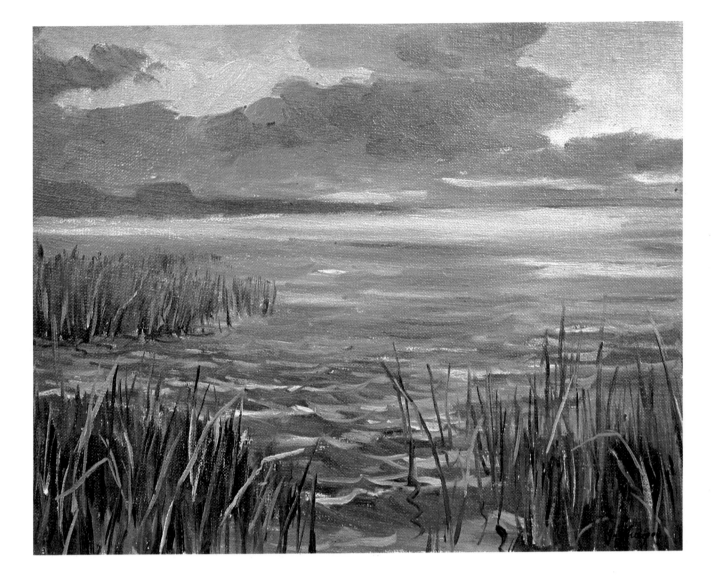

Step 7. Adding more burnt sienna to the marsh grass mixture, the round brush adds strokes of warmer color to the patch of grass in the middleground. Moving on to the grass in the immediate foreground, the brush adds more blades with this warm mixture. Then the brush switches to a darker mixture of ultramarine blue, burnt sienna, and yellow ochre to strike in the darkest blades of grass in the immediate foreground. Over these dark strokes, the tip of the brush draws sunstruck blades of grass with yellow ochre and white. As these last strokes blend slightly with the wet undertone, the white and yellow ochre mixture turns a bit darker and cooler. Like Demonstration 3, the final painting of the salt marsh shows how just three colors can produce a surprisingly rich range of sky and water tones. The bright patches of sky, the dark clouds, the sunlit water, and the darker areas of the water are all painted with cobalt blue, yellow ochre, and alizarin crimson, plus white.

Step 1. In a storm, the clouds and waves move so swiftly that it's often difficult to record their forms in the preliminary brush drawing. The important thing is to focus your attention on just a few forms, isolate them from all the turmoil, and draw them with a few simple strokes. The tip of a small bristle brush draws the shape of one big wave against the horizon, some smaller waves in the foreground, and just two big clouds. The brush drawing is made with phthalocyanine blue and burnt sienna, diluted with turpentine.

Step 2. Since the sky normally establishes the color of the sea, a large bristle brush begins work on the sky first. At the horizon, the dark tone is painted with diagonal strokes of phthalocyanine blue, burnt sienna, a touch of yellow ochre, and white. More white is added to this mixture for the paler patch of sky just above this dark area. Above this pale tone, the darker tone again contains more phthalocyanine blue and burnt sienna, with less white. The rapid, diagonal brushwork emphasizes the movement of the windblown clouds.

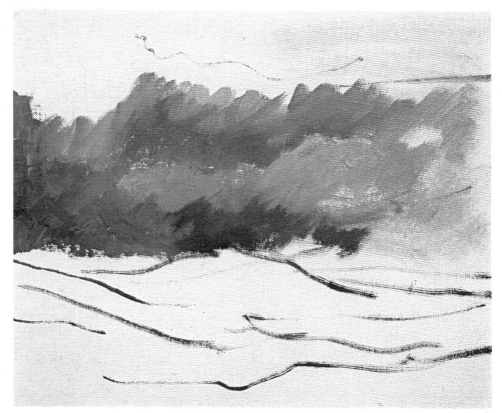

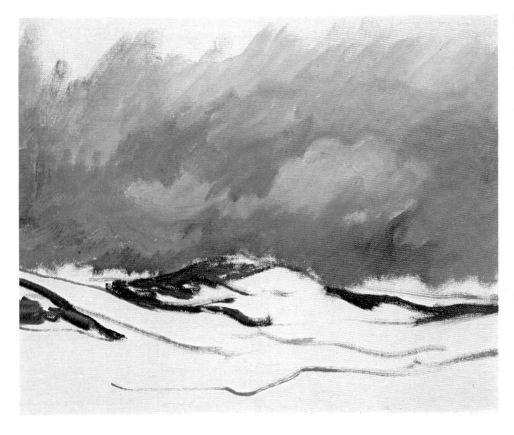

Step 3. The lower sky is covered with a rich blue tone that consists mainly of phthalocyanine blue, burnt sienna, and white, with just a touch of yellow ochre. More white, burnt sienna, and yellow ochre are added to this mixture for the pale tone in the upper sky. A bristle brush uses this mixture to shape the pale cloud that hangs just above the horizon. Then the dark edges of the waves are painted with flowing strokes of phthalocyanine blue and burnt sienna, lightened with just a touch of white to "bring out" the color.

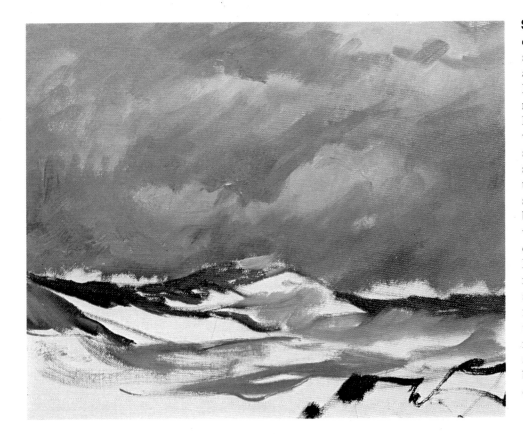

Step 4. The upper sky is darkened with diagonal strokes of the rich tone that appears above the horizon. Now the sky consists of alternating patches of dark and light. At either side of the big wave, the lower edge of the sky remains bare canvas to suggest light breaking through at the horizon. Dark strokes of phthalocyanine blue, burnt sienna, and a little white complete the silhouette of the sea against the sky. More white is added to this mixture for the strokes that sweep across the waves in the foreground and the foam at the crest of the big wave. The rocks in the lower right are also phthalocyanine blue and burnt sienna—but the mixture contains more burnt sienna.

Step 5. The dark shape of the big wave, silhouetted against the sky, is painted with slashing, horizontal and diagonal strokes of phthalocyanine blue and burnt sienna, heightened with just a touch of white. Varying amounts of white are added to this basic mixture to paint the foreground waves with back-and-forth, curving strokes that match the wave action. The sky is darkened with this mixture, and a dark cloud replaces the pale cloud that first appeared in Step 3. The rocks are painted with knife strokes of phthalocyanine blue and enough burnt sienna to create a warm tone. The tip of a round brush begins to paint the lines of foam with thick white, tinted with the water mixture.

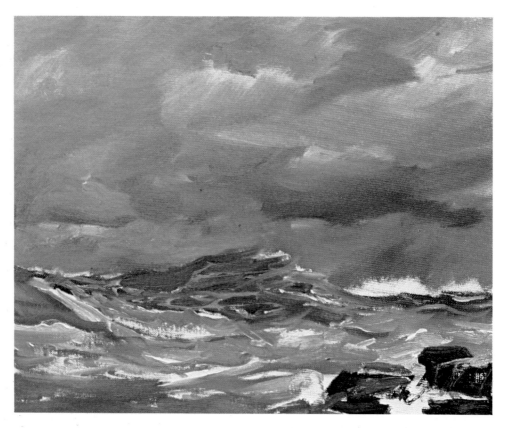

Step 6. The round, softhair brush continues to add trickles of foam to the big, dark wave. The darker trickles are phthalocyanine blue, a little burnt sienna, and white. The paler trickles are *almost* pure white tinted with a faint touch of yellow ochre. A bristle brush picks up a thick load of this mixture to draw some streaks of sunny sky at the horizon, just below the dark clouds and on either side of the big wave. Thick strokes of foam are carried across the foreground with the tip of a small bristle brush plus an occasional touch of the knife blade. A bristle brush carries this mixture into the lower right corner to suggest surf breaking over the rocks and splashing between the dark forms.

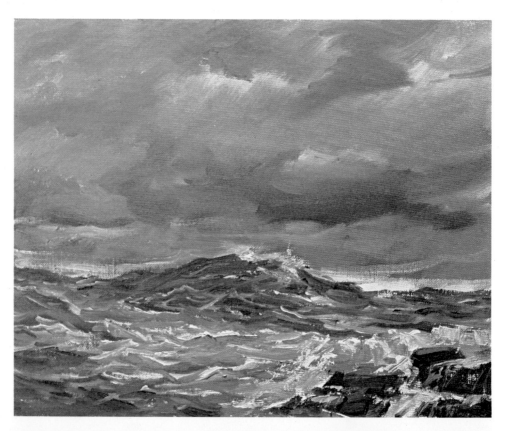

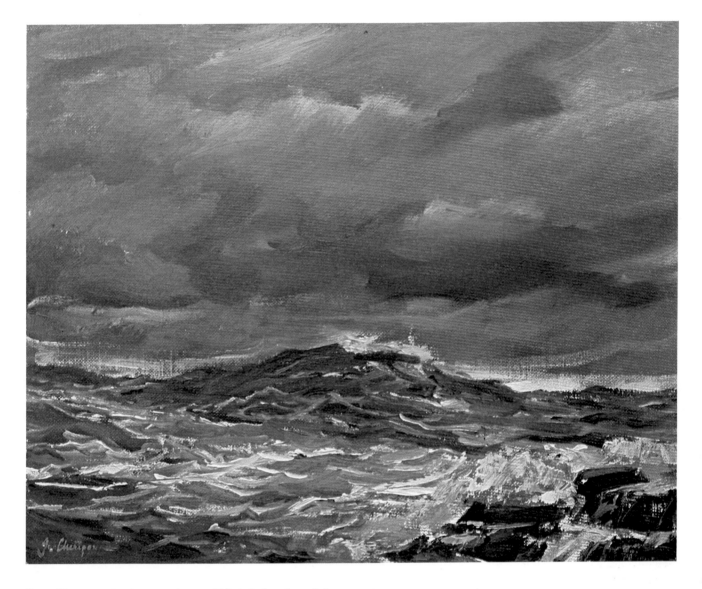

Step 7. In the final stage, the small bristle brush and the knife continue to build up the foam in the foreground to contrast with the dark shape of the wave at the horizon. To emphasize the darkness of the wave, the crest of the wave is crowned with thick strokes of foam. In the upper sky, more pale strokes are added to extend the pale edges of the clouds—and to suggest some windblown wisps of cloud at the very top of the canvas. At first glance, the finished picture is almost entirely blue and white. However, in this final stage, a small bristle brush enlivens the sea and sky with some touches of other colors—which you may have begun to notice in Step 6. Look closely at the waves and you'll see warm touches of burnt sienna, plus an occasional hint of green where yellow ochre has been blended into the wet blue of the waves. As your eye moves across the sky, you'll see where the brush has blended burnt sienna and even an occasional hint of alizarin crimson into the underlying cool tone. Although these last few color notes are almost invisible, they add richness and variety.

Step 1. For painting sunrises and sunsets—and skies in general—George Cherepov favors a technique adapted from the impressionists. A simple, preliminary brush drawing defines the horizon and the shapes of the shore with cobalt blue diluted with turpentine. Then the sky is covered with a dense mosaic of brushstrokes of cobalt blue and white, applied with a bristle brush. The strokes are darkest at the top of the sky, where they overlap to produce a fairly solid tone. As the brush works its way downward toward the horizon, the strokes contain more white and are more widely spaced, leaving gaps between them for the other colors which will come next.

Step 2. The golden tones of the sky come next. Yellow ochre and white are blended on the palette and then carried across the sky in a series of separate touches. Some of these strokes fall between the blue strokes applied in Step 1. Other strokes of yellow ochre and white simply overlap the underlying blue tone. The yellow strokes start just below the top of the canvas, leaving the deepest blue of the sky untouched. As the yellow strokes move down toward the horizon, they contain more white.

Step 3. Alizarin crimson is blended with white on the palette to produce a delicate pink. Starting slightly further down than the yellow strokes in Step 2, the brush applies separate strokes of this pink. These strokes begin to overlap the blue and yellow strokes and mix with the wet undertone. The bristle brush continues to add yellow strokes in the lower sky, carrying these touches of color down to the horizon. At the horizon, a hint of cadmium yellow is added to the mixture of yellow ochre and white. The pink strokes are concentrated across the center of the sky, while the top is predominantly blue and the lower sky is predominantly yellow.

Step 4. A large bristle brush blends the blue, pink, and yellow touches together with short strokes. The big brush doesn't move across the sky with continuous, horizontal or vertical strokes; this would produce a monotonous, mechanically smooth tone. The short strokes of the big brush preserve the lively brushwork of Steps 1, 2, and 3 so that the sky retains a suggestion of the original strokes. Thus, the sky seems to vibrate with light. The golden glow of the sunrise is strongest just above the horizon.

Step 5. The dark tones of the sea are painted with darker, richer strokes of the same colors used for the sky: cobalt blue, alizarin crimson, yellow ochre, and white. More white is added to this mixture for the shadowy face of the surf. More alizarin crimson and white are added to this mixture for the dark clouds. The palest clouds are strokes of yellow ochre and white, made more brilliant with a touch of cadmium yellow. The sandy tones of the beach are painted with horizontal strokes of yellow ochre and white, darkened with a touch of cobalt blue and alizarin crimson.

Step 6. Still working with various mixtures of cobalt blue, alizarin crimson, yellow ochre, and white, a bristle brush covers the sandy beach in the foreground. You can see where the strokes sometimes contain more cobalt blue or yellow ochre. The bright pools that wander across the sand are painted with thick strokes of yellow ochre and white, darkened with a slight touch of the sandy tone. The dark lines of the distant waves and the darks of the crashing wave are painted with ultramarine blue brightened with a touch of viridian. More white is added to this mixture for the scrubby up-and-down strokes that darken the surf. The tip of a round brush uses the cloud mixtures to paint gulls.

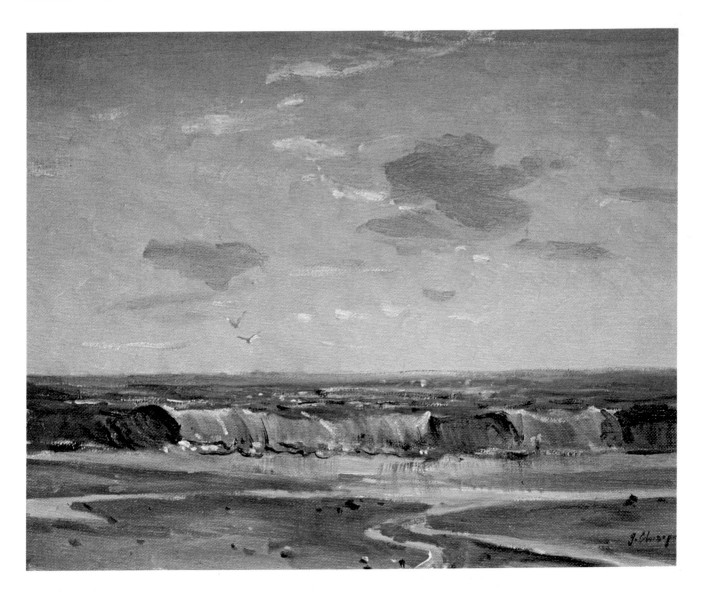

Step 7. The oncoming wave is enriched with strokes of ultramarine blue, viridian, yellow ochre, and white. Notice how two sections of the crashing surf—at the right end of the wave—have been overpainted with this mixture. (Compare Step 6.) Now the eye goes directly to the patch of surf just left of center. This same mixture of ultramarine blue, viridian, yellow ochre, and white is blended into the sand in the foreground, which now has a richer, more varied color. The shapes of the sand are darker and more clearly defined, contrasting more strongly with the pale trickles of water that move across the beach. This contrast makes the wet parts of the beach shine more brightly. The tip of a round brush traces shadow lines around the surf of the crashing wave with ultramarine blue and viridian. Tiny touches of this same dark mixture suggest pebbles scattered across the beach. Small touches of pure white tinted with yellow ochre brighten the sunlit top of the wave, strengthen the reflection of the sunlight on the distant sea, and add glistening tops to a few pebbles in the foreground. Like most good pictures of sunrises and sunsets, this coastal scene avoids garish colors. The colors are clear, but delicate. The brightest tone appears just above the horizon and is surrounded by more subdued colors.

Step 1. Although fog tends to make the shapes along the shoreline pale and remote, it's important to begin with a brush drawing that defines these shapes clearly. The brush drawing is executed in ultramarine blue, softened with a touch of burnt umber, and diluted with turpentine. Although the distant rocky islands will be obscured by the fog, their silhouettes are important to the pictorial design, so the brush draws the rocky shapes carefully. Notice that the beach and rocks in the foreground are drawn with thicker, darker strokes to indicate that they're closer to the viewer.

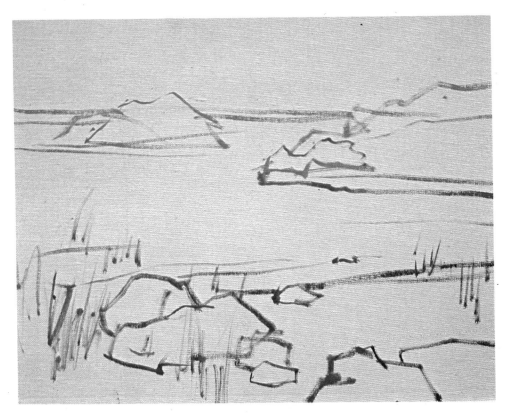

Step 2. In the preceding demonstration, you've seen a very effective technique for painting the effects of light and atmosphere. Now the fog is painted in the same way, but with different color combinations. First, the sky and sea are covered with separate strokes of yellow ochre and white, spaced apart so that bare canvas shows between them. On a foggy day, the sky and water tend to be one continuous color—with little or no break at the horizon. They're painted in one continuous operation.

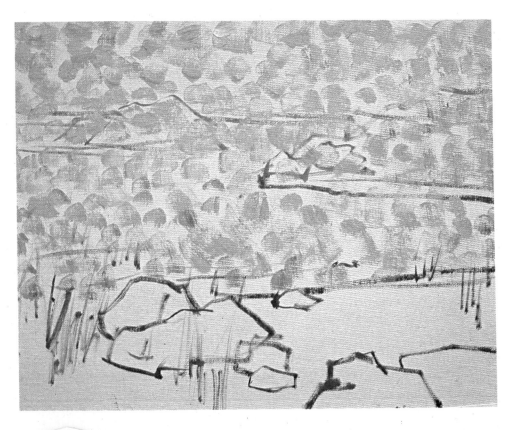

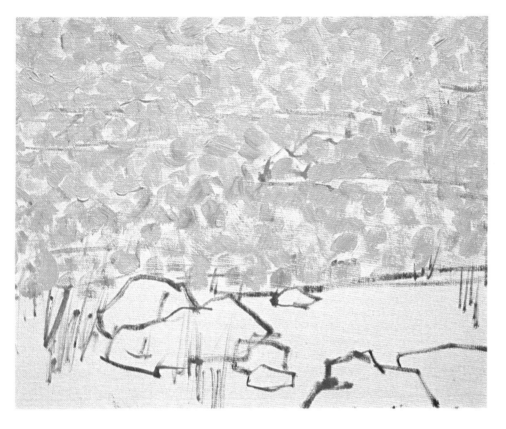

Step 3. Alizarin crimson, ultramarine blue, yellow ochre, and lots of white are blended on the palette to produce the next tone. This tone is applied in separate strokes that sometimes fill the gaps between the strokes applied in Step 2 and sometimes overlap the wet color. Where the strokes overlap, they tend to blend softly, although the brush doesn't actually scrub the two colors together. The underlying brush lines of the horizon and distant islands are beginning to disappear, but enough lines remain to define the overall shapes.

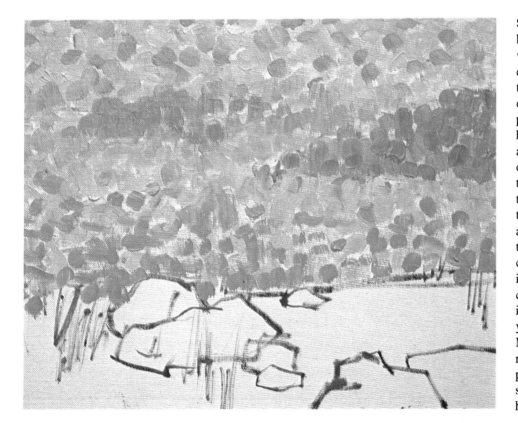

Step 4. Ultramarine blue, a hint of yellow ochre, and white are blended on the palette and individual strokes of this new mixture are carried over the sky and sea to complete the "mosaic." Notice how the strokes are scattered across the sky, densely concentrated over the shapes of the distant islands, then scattered across the water near the shore—while the water around the islands is practically untouched. The islands contain some darker strokes in which a touch of alizarin crimson has been blended into the ultramarine blue, yellow ochre, and white. Now the brush lines of the rocky islands have disappeared beneath the thick strokes of paint, but their silhouettes have been filled in.

Step 5. Working with short, diagonal and vertical strokes, a big bristle brush begins to blend the sky, the rocky islands, and the water around them. The quick, irregular touches of the brush preserve the lively texture that suggests the flickering light creeping through the fog. As the brush blends the darker tones of the islands, it redefines the shapes that were originally drawn in Step 1. The shadow side of the island at the right is painted with thick, ragged strokes of ultramarine blue, burnt sienna, yellow ochre, and white, as are the shadow sides of the rocks on the beach; the lighted top is simply painted with the color that's accumulated on the big bristle brush that blends the sky and water.

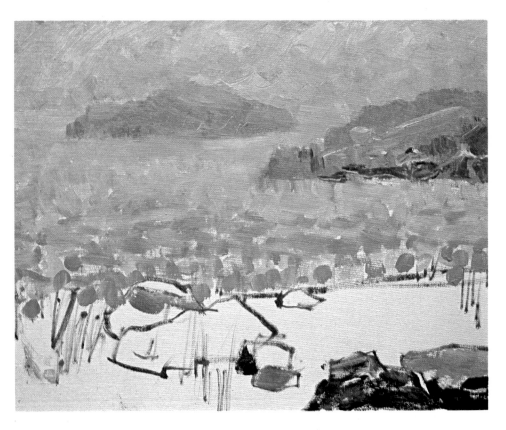

Step 6. Now the big brush blends the water at the edge of the beach, adding some horizontal strokes of ultramarine blue, yellow ochre, and white to suggest gentle waves. A stroke of yellow ochre and white indicates a line of foam. The big brush then goes back to redefine the shape of the more distant island. The rocky island that's closer to shore is built up with small, thick strokes of various mixtures of ultramarine blue, burnt sienna, yellow ochre, and white. A bristle brush begins to build the forms of the rocks at the center of the beach; the shadow sides are ultramarine blue, burnt sienna, and just a little white. The sand is the same mixture—but with more yellow ochre and white.

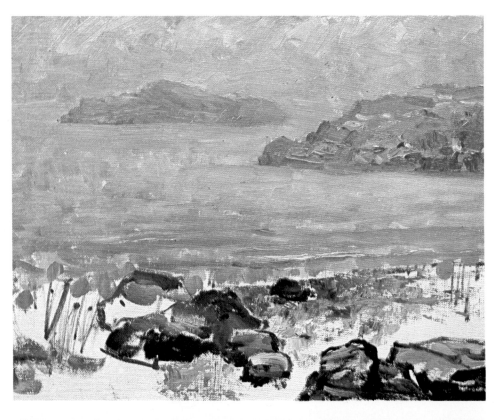

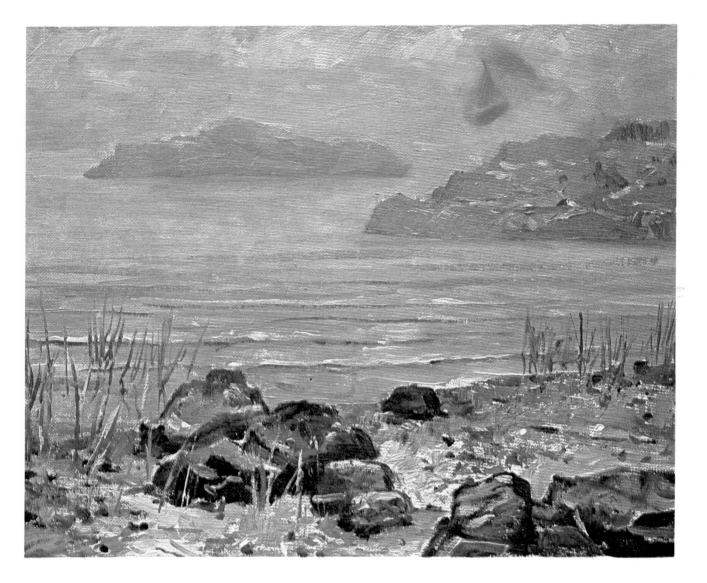

Step 7. The bright continues to cover the beach with short, ragged strokes of thick color. The sunlit patches of sand are mainly yellow ochre and white, with just a hint of ultramarine blue and burnt sienna added to the mixture. The cooler, shadowy areas of the beach contain more ultramarine blue and less white. The warm patches of sand contain more burnt sienna. The cool tops of the rocks are painted with the same mixture that's used to paint the cool shadows on the sand. Notice how an occasional touch of burnt sienna, yellow ochre, and white brightens the generally cool tone of the rocks. A few rocks have touches of bright light on the edges that face the sky; these are thick strokes of white tinted with yellow ochre and a speck of ultramarine blue. A round, softhair brush returns to the water, indicating the dark lines of incoming waves with ultramarine blue, yellow ochre, alizarin crimson, and white. The same brush adds lines of foam with yellow ochre and white.

The tip of this brush adds coarse stalks of beach grass with a mixture of viridian, yellow ochre, and white, occasionally warmed with a touch of burnt sienna. The sunstruck blades of grass are yellow ochre and white, heightened with a touch of cadmium yellow. The round brush completes the beach with small touches of ultramarine blue, burnt sienna, and white to suggest scattered pebbles among the rocks. In the finished painting, all the original brush lines have disappeared, but most of the shapes have been followed carefully, except for the most distant island, which has been redesigned to make its shape lower and less prominent. The sky and water are brushed together so that the horizon line virtually disappears, except at the extreme left. This coastal landscape is an example of *aerial perspective*: the brightest colors and the strongest contrasts are in the foreground, while objects gradually grow paler and cooler as they recede into the distance.

Step 1. Rocks are hard and they should *look* hard. Thus, the preliminary brush drawing renders these rock formations with straight, hard lines. The foreground rocks are simply drawn as silhouettes enclosing jagged shape of a tidepool. The big rock formation—the focal point of the picture—is drawn in greater detail. The round, softhair brush defines its silhouette with ultramarine blue and burnt sienna diluted with turpentine, then goes on to define the shapes of the shadows within the rock.

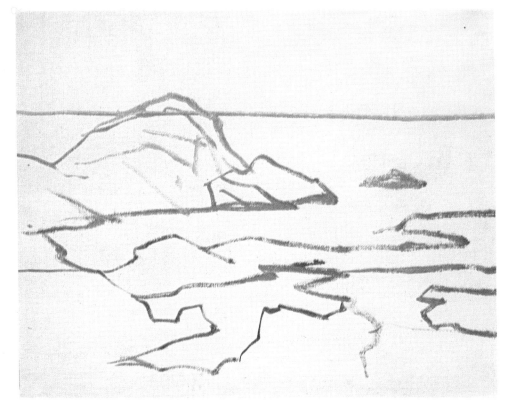

Step 2. The dark, warm tones of the rocks in the center are painted with straight, diagonal and horizontal strokes of burnt umber, yellow ochre, ultramarine blue, and white—with more ultramarine blue in the shadows. The paler, cooler tone of the rocks in the immediate foreground is a mixture of ultramarine blue, burnt umber, and white, applied with a big bristle brush that pulls the strokes downward to emphasize the blocky character of the shapes. The thick color contains almost no painting medium so that the heavily loaded brush drags the paint over the textured surface of the canvas; the weave of the canvas comes through to enhance the roughness of the rocks.

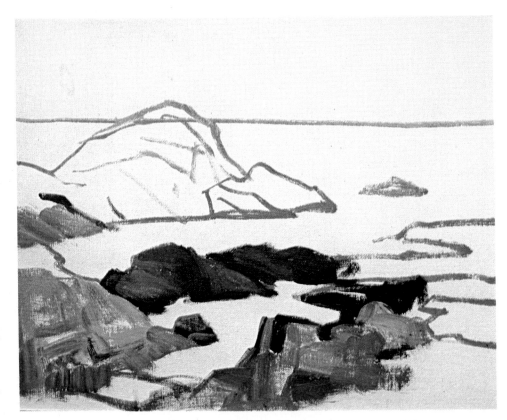

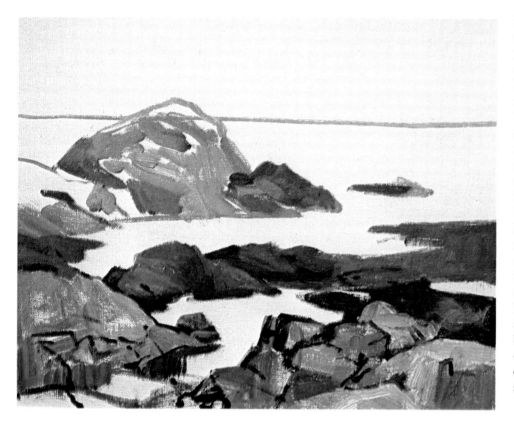

Step 3. The big rock that dominates the picture is painted with thick, straight strokes of ultramarine blue, burnt umber, and white, with more blue in the shadows. Work continues on the foreground rocks with this same mixture; the sides of the rocks are painted with vertical and diagonal strokes, while the tops are often painted with horizontal strokes. A small bristle brush picks up a dark mixture of ultramarine blue and burnt sienna to strike in the dark lines of the shadows and the cracks. A bristle brush goes back over dark, seaweed-covered rocks with burnt sienna, viridian, yellow ochre, and white, and then carries this mixture along the shoreline.

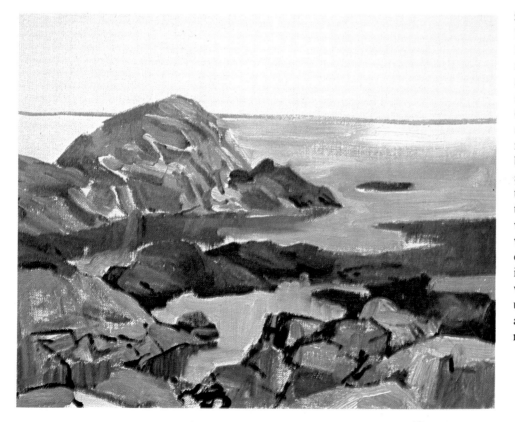

Step 4. A large bristle brush begins to cover the sea with horizontal strokes of ultramarine blue, burnt umber, and white. With a darker version of this same mixture (containing less white) a small bristle brush places more shadow strokes on the big rock formation. The dark slope of the big rock formation and the dark reflection in the water are both painted with ultramarine blue and white, softened with a touch of burnt umber. The tidepool in the foreground is painted with the same mixture that's used for the distant water, but a hint of yellow ochre and more white are added.

Step 5. The sea is now covered with long, horizontal strokes of ultramarine blue, burnt umber, and lots of white—with more white near the horizon, where the sun shines on the water. The sky is painted by the method you've already seen, starting with separate strokes of ultramarine blue and white. A touch of viridian is added to the original mixture of ultramarine blue, burnt umber, and white to suggest the grassy slopes of the big rock formation. Small touches of viridian, burnt sienna, yellow ochre, and white accentuate the weedy texture of the seaweed-covered rocks and shore.

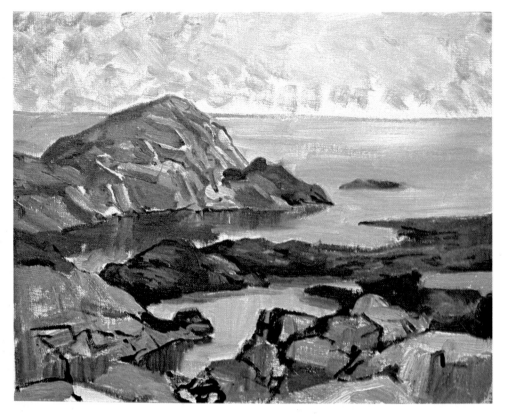

Step 6. Work continues on the sky with strokes of alizarin crimson and white, and yellow ochre and white, which the brush has already begun to blend. Notice how additional white has been brushed into the section of the overcast sky where the sun begins to break through. A strip of distant shore is placed at the horizon with ultramarine blue, alizarin crimson, yellow ochre, and lots of white to make this coastline seem far away.

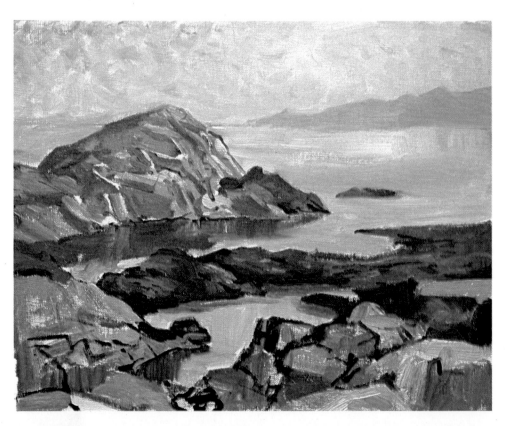

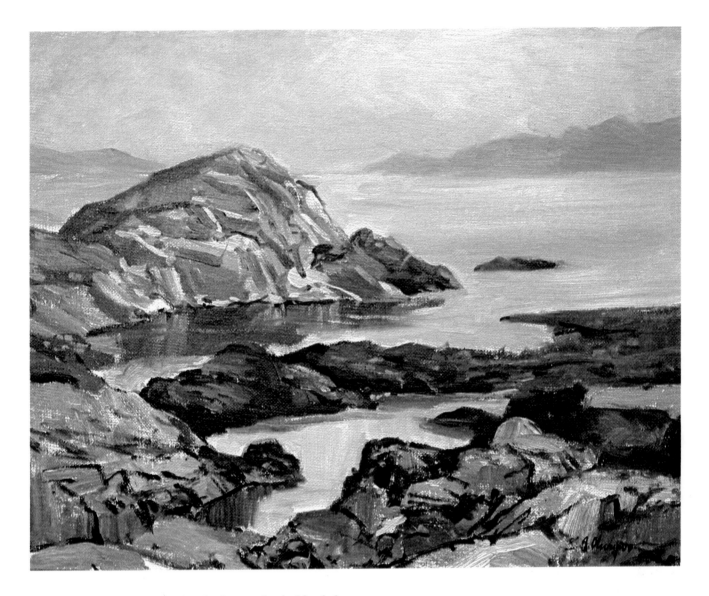

Step 7. In this final stage, the sky is completely blended, but you can still see traces of the original brushwork. In the process of blending the sky, the brush softens the edge of the distant shoreline at the right, then adds another piece of shoreline along the horizon at the left. The tip of a small bristle brush accentuates the lighted planes of the biggest rock formation with straight strokes of thick color—ultramarine blue, burnt umber, yellow ochre, and lots of white. The tip of a round brush carries horizontal lines of this mixture across the dark reflection in the water to suggest a few ripples. The tone of the seaweed is enriched with short, thick strokes of viridian, burnt sienna, yellow ochre, and white. A round, softhair brush wanders over the rocks in the foreground, placing scattered touches of warm color among the cool tones: the small strokes on the rock at the extreme left are yellow ochre, cadmium yellow, burnt sienna, and white, while the warm touches in the central rocks are burnt sienna with a little ultramarine blue and white. Then the tip of the round brush picks up a rich, dark mixture of ultramarine blue and burnt sienna to add more cracks to the foreground rocks and redefine their dark edges.

Step 1. A round softhair brush executes the preliminary drawing in two colors. Because the headland will contain a variety of cool tones, it's painted with ultramarine blue and a touch of burnt umber diluted with turpentine. This same color is used to place the horizon and to draw the distant headland on the left. The patterns of the sandy beach are drawn with a warmer version of the same mixture, but with less ultramarine blue and more burnt umber. The tidepools on the sand form a particularly interesting pattern, and these are traced carefully, even though they'll be redesigned later on. At this point, the composition looks best with a bare sky, but this will change too.

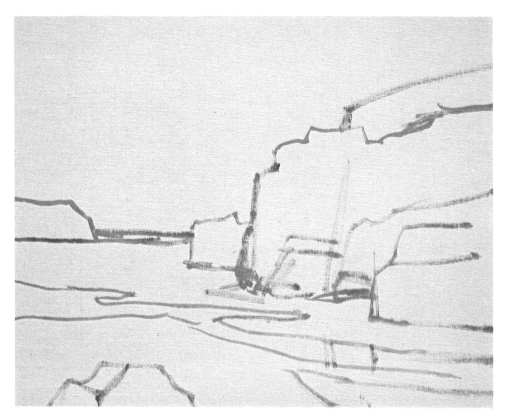

Step 2. The shadow planes of the big headland are the darkest notes in the picture, so they're painted first with broad, thick strokes of ultramarine blue, burnt sienna, yellow ochre, and white. The darkest shadows contain more burnt sienna and less white. Notice how the vertical strokes follow the planes of the rocks. Just beyond the big headland, at the center of the picture, a more distant cliff is painted in a cooler tone: ultramarine blue, alizarin crimson, yellow ochre, and white. The color is smoother and more fluid than the big headland, which is painted with rougher, thicker strokes to bring it closer to the viewer.

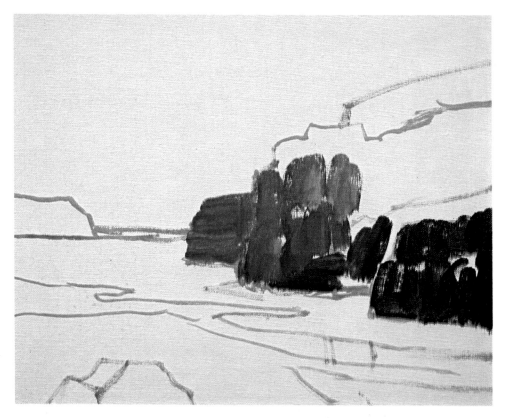

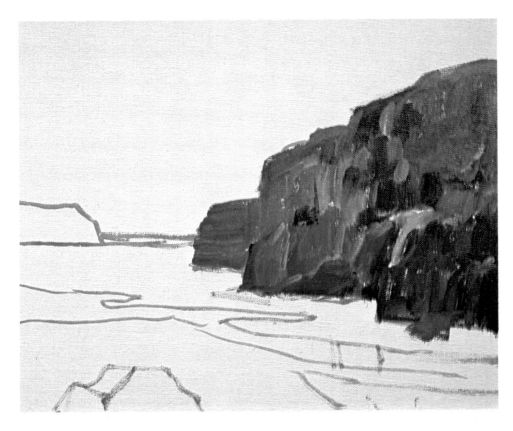

Step 3. The entire shape of the big headland is covered with vertical strokes of thick color. These strokes are all various mixtures of ultramarine blue, burnt sienna, yellow ochre, and white. You can see where some strokes contain more burnt sienna, while others contain more ultramarine blue or more yellow ochre. Notice that the very top of the cliff—which receives the direct light of the sky—contains more blue. Patches of grass are indicated by substituting viridian for ultramarine blue in several strokes.

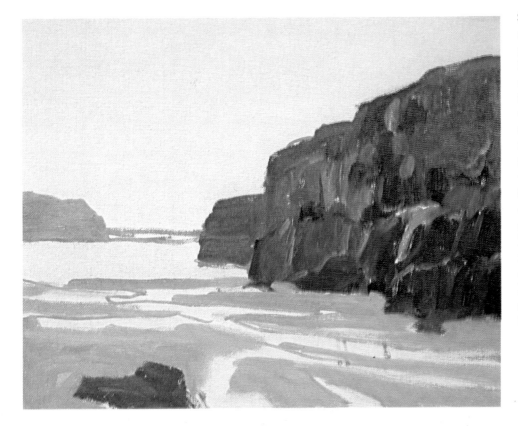

Step 4. The distant headland at the left is painted with a pale mixture of ultramarine blue, alizarin crimson, yellow ochre, and white. The soft tone of the sand is painted with long, smooth strokes of creamy color: a subtle mixture of yellow ochre, burnt umber, ultramarine blue, and white. Compare Step 4 with Step 3 to see how the pattern of the tidepools has been redesigned to create a path that leads the eye into the picture from the bottom edge of the canvas. The dark rock at the lower left is painted with the same mixtures used for the big headland.

Step 5. The sky needs a big, bold shape to balance the massive shape of the headland. So a large bristle brush paints an irregular cloud formation with dark and light strokes of the same mixture that was used to paint the small headland on the left. The clouds are ultramarine blue, alizarin crimson, yellow ochre, and white, with less white in the dark clouds at the top of the canvas. Notice that most of the cloud shape is paler than the distant headland at the left, so the clouds are obviously more remote than the cliff.

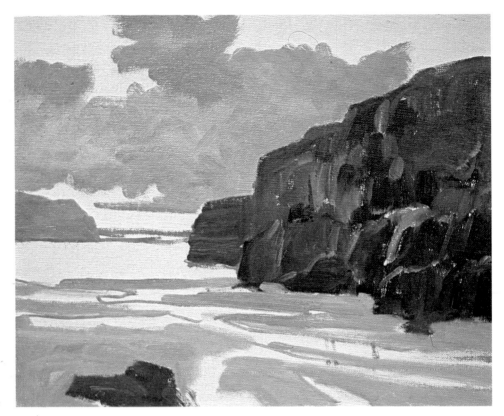

Step 6. The overcast sky is painted with yellow ochre and white, subdued with just a hint of the darker cloud mixture. As the brush paints the surrounding sky, the edges of the clouds are blurred and softened. The sky mixture is carried down into the bright tidepools. More blue is blended into the cloud mixture to paint the dark sea at the horizon; then a few strokes of this mixture are brushed over the big headland at the right and the small headland at the center to suggest the skylight falling on the rocks. Darkened, this mixture becomes the reflection in the tidepools. Lightened, this mixture is brushed into the tidepools in the foreground and carried over the water's edge.

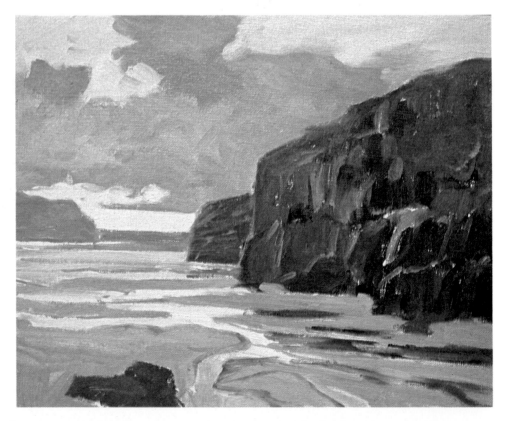

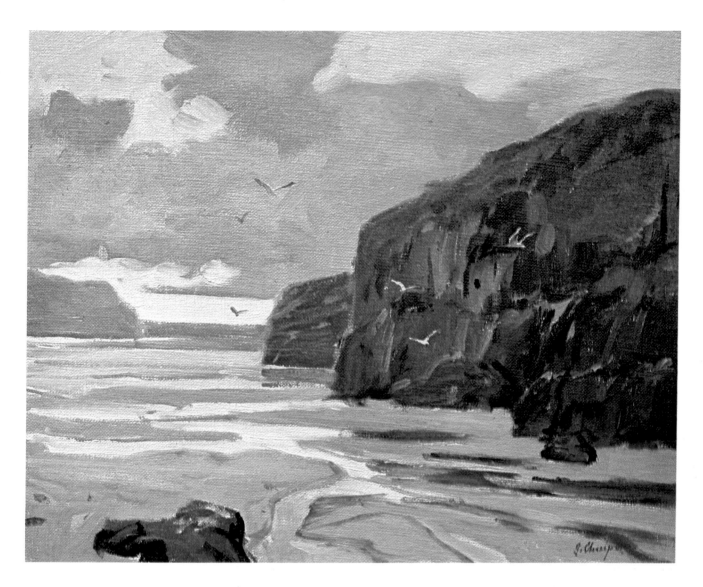

Step 7. At the end of Step 6, the tip of a round softhair brush began to sharpen the shadowy edges of the tidepools with slender strokes of the cloud mixture. This sharpening up operation continues as the round brush adds dark lines of shadow to the big headland and the rocks in the lower left. These dark strokes are burnt umber and ivory black diluted with enough painting medium to make the brush move smoothly over the canvas. Several more grassy patches are added to the top of the cliff with ultramarine blue, viridian, yellow ochre, and white. Small strokes of bright light are swiftly brushed over the top of the rock at the lower left with pure white tinted with a speck of the cloud mixture. The tip of the round brush uses this mixture to paint the pale shapes of the gulls silhouetted against the dark cliff. More blue is added to the cloud mixture to paint the dark gulls silhouetted against the sky.

Step 1. The lines of sand dunes are soft and sinuous, but certainly not shapeless. Their curves must be drawn with great precision so that the design of the picture is clearly determined from the very beginning. The tip of a round softhair brush executes these lovely curves with a mixture of cobalt blue, alizarin crimson, yellow ochre, and white—which will become the basic palette for the painting.

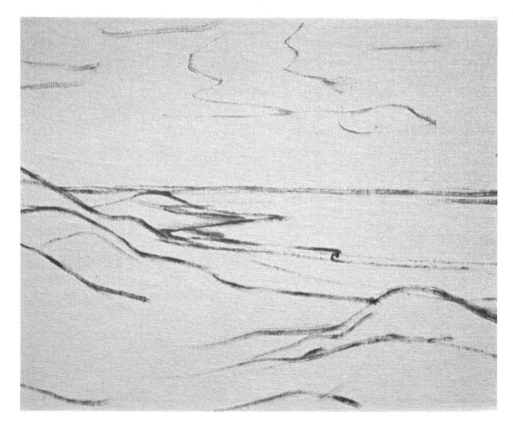

Step 2. The shape of the distant water is painted with long, smooth, horizontal strokes of cobalt blue, softened with touches of alizarin crimson and yellow ochre, plus some white to brighten the blue. At the edge of the beach, more yellow ochre is blended into the water. The sunlit area of the sand is covered with thin, casual strokes of yellow ochre and white, made more subdued by adding a speck of yellow ochre and alizarin crimson. Now the strongest contrast in the painting has been established—the contrast between the dark note of the sea and the light note of the sunlit sand. All the other tones in the painting will fall somewhere between these two.

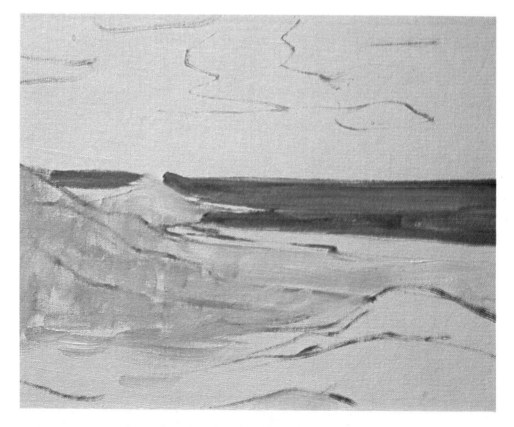

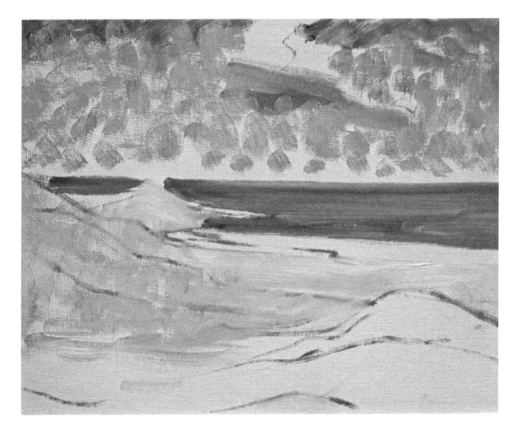

Step 3. By now, you're familiar with this method of painting the sky. Once again, the sky is first covered with separate strokes of cobalt blue and white. The strokes are darkest and closest together at the top of the sky, gradually growing lighter and sparser as the brush approaches the horizon. The shadowy underside of the cloud is painted with the same mixture that was used to paint the sea, but with slightly more yellow ochre for greater warmth.

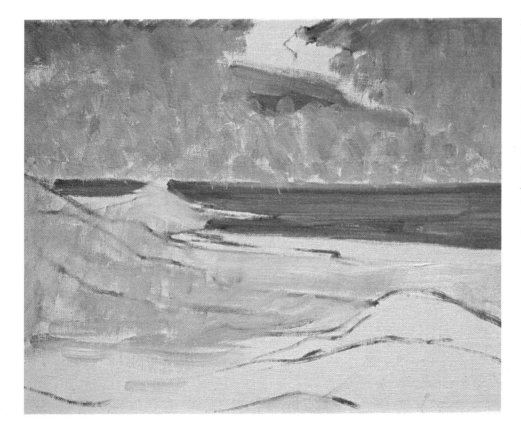

Step 4. Yellow ochre and white are blended on the palette and then this mixture is carried across the sky in a series of separate strokes. These strokes sometimes fall between the touches of cobalt blue and sometimes overlap the blue. The brush makes no attempt to blend the two hues just yet, but as the yellow-laden brush moves over the wet blue undertone, the two colors tend to merge.

Step 5. When the small strokes of alizarin crimson and white have been added, a big bristle brush blends all these colors together with short strokes. You can see that the warmer, paler tones are concentrated in the lower sky. The lighted areas of the clouds are painted with white tinted with touches of yellow ochre, alizarin crimson, and cobalt blue. A darker version of this mixture is brushed across the shadowy under-sides of the clouds. The pale wisps of cloud at the upper right and left are quick strokes of the same mixture that's used to paint the lighted tops of the bigger clouds. The tip of a round brush pulls this mixture across the sea with horizontal strokes that suggest sunshine on the waves.

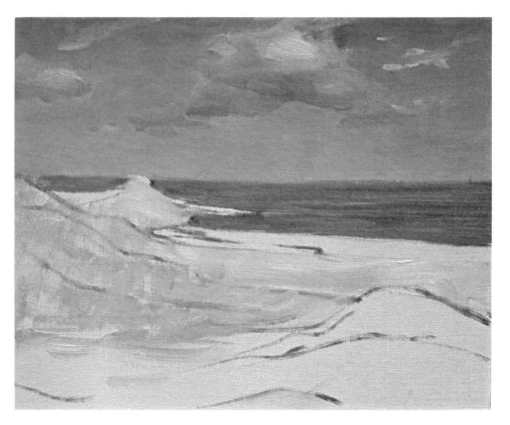

Step 6. A cloud often casts its shadow on the landscape beneath. Such a *cloud shadow*, as it's called, can act as a handsome "frame" for the sunlit area of the land-scape. Here, a cloud shadow is painted over the beach in the foreground with the same mixture that's used to paint the shadowy undersides of the clouds: cobalt blue, alizarin crimson, yellow ochre, and white. The long, curving brushstrokes of creamy color follow the curves of the dunes. A small bristle brush places shadows on the more distant dunes with this same mixture. Notice how the sun-lit beach is brightened by the contrasting shadow tone.

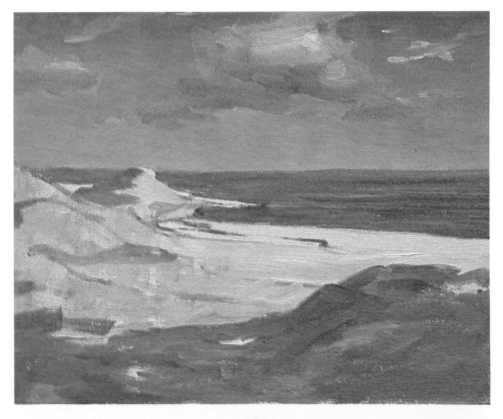

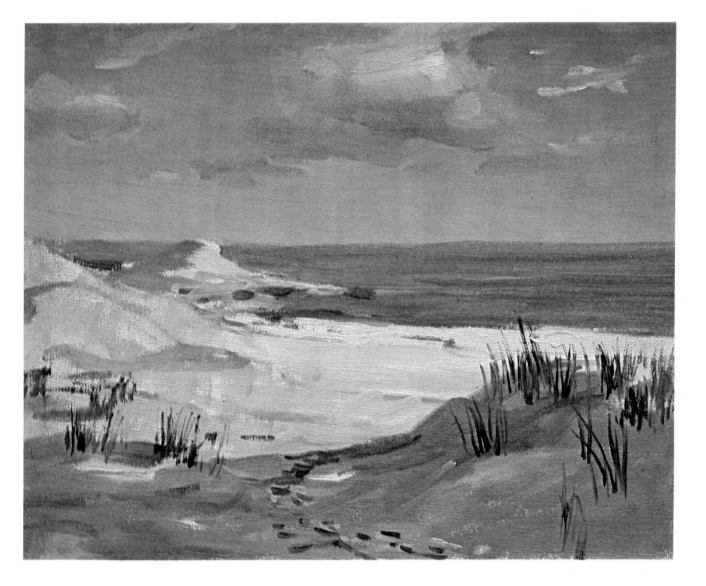

Step 7. To strengthen the contrast between the sunlit sand and the dark tone of the sea, a bristle brush sharpens the edge of the beach with thick strokes of yellow ochre and white, softened with just a speck of cobalt blue and alizarin crimson. The sea mixture is darkened with more cobalt blue for the touches of shadow where the distant dunes meet the edge of the sea. Small strokes of this same mixture curve upward from the lower edge of the canvas to suggest a trail of pebbles, seaweed, or other shoreline debris. Then ultramarine blue, cadmium yellow, and burnt umber are blended on the palette with plenty of medium to produce a fluid mixture for the beach grass. The tip of a round softhair brush places clumps of this grass in the foreground with rapid, spontaneous strokes; the tip of the brush is pressed down and then pulled swiftly upward, following the curve of each blade.

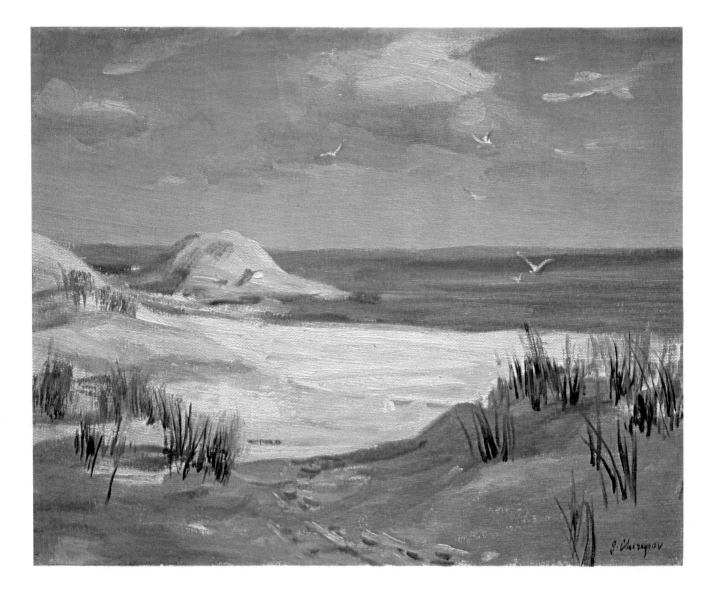

Step 8. A big bristle brush brightens the tone of the sunlit sand with long, sweeping strokes of yellow ochre and white, with an occasional touch of burnt sienna which you can see in the warm streaks and the warm patches at the left. The shape of the distant dune is enlarged and rounded with thick strokes of this mixture. The shadow side of the big dune is warmed with yellow ochre, burnt sienna, and white; then the dark shadows are restated with the original mixture of cobalt blue, alizarin crimson, yellow ochre, and white. The beach grass is also brightened with strokes of viridian, burnt sienna, and white to emphasize those patches of grass that are silhouetted against the sunlight. Touches of the warm, sandy mixture are carried over the foreground where they mingle with the dark strokes placed there in Step 7. A single horizontal stroke creates a cloud shadow on the water with cobalt blue, yellow ochre, and white. The tip of a round brush paints the sunlit shapes of the gulls with yellow ochre and white. It's worthwhile to study the colors of the finished painting to see how the light of the sky influences every aspect of the subject. The sea reflects the tone of the sky, of course. But the colors of the beach are influenced just as strongly. The crystalline sand in the center reflects the warm sunlight, while the shadowy sand in the foreground reflects the cooler tone of the sky.

Panoramas and Close-ups. When you're standing on a beach or at the top of a headland, you see an incredible panorama that's just too much to include in one painting. You've got to zero in on just one small part of the panorama and paint *that*. You can *suggest* the vastness of the sea by painting one big cliff, a couple of smaller ones; a curve of beach, two long waves, and a few clouds. If you try to include much more, you'll actually *lose* that sense of space and majesty—which you'll achieve if you concentrate on just a few big shapes. It's usually best to focus on some memorable close-up. Don't paint the entire length of the wave, but concentrate on that section of the wave that's crashing into the big rock formation. Don't try to paint all the clouds in the sky, but just those few clouds with the bright light of the sun behind them—and just two or three shining tidepools that reflect the sun's rays.

Finding the Right Spot. Before you set up your painting gear, walk around for a few minutes to find the vantage point or the angle from which the subject looks most appealing. Try to find the spot where you can see the curve of the beach moving gracefully toward that big rock formation—so you can design the picture to lead the eye along the edge of the beach to the center of interest. If you walk around to the shadow side of the cliff, that big, craggy shape may look darker and more impressive than it does from the sunlit side. The beautiful reflections in a tidepool may be easier to see if you climb up on a rock.

Looking for Ideas. How do you spot a really good pictorial idea? It's not enough to fall in love with one handsome motif—like a cliff, a dune, or a tidepool—and just paint that. A successful seascape is a *combination* of elements that work well together. One thing to look for is conflict or contrast; another is repetition or harmony. The most common conflict—and it's always wonderful—is the graceful form of a wave battling the jagged form of a rock. But look for other contrasts, such as the calm tidepool with the turbulent storm clouds overhead; or the overcast day with the flashes of sunlight breaking through the gray clouds and shining on the wet beach. But repetition or harmony may be equally fascinating: the long, low lines of the waves rolling into shore, echoed by long, lazy clouds just above the horizon; or the exploding shapes of the surf repeated in the billowing forms of the clouds.

Orchestrating the Picture. As you can see, the whole secret of a successful seascape is to find the right *interplay* of pictorial elements. Of course, you won't find the exact combination ready-made. Nature tends to give you scattered raw material which it's your job to organize. You may want to emphasize the contrast between the calm sea and the distant storm clouds—but those clouds may be too far off, too small, and not dark enough. You're perfectly free to make those clouds bigger and darker. You can also exaggerate the tranquility of the sea by making the waves longer and lower. If you want to make that cliff look taller, you can move some low, flat rocks up the beach to the foot of the cliff, where their horizontal lines will contrast nicely with the vertical lines of the cliff.

Keep Looking. Make a point of looking at the same coastal landscape under different light conditions. At one moment, a subject may seem hopelessly dull. But an hour later, the light comes from a slightly different direction and that subject is transformed. At noon, those shoreline rocks may not impress you at all because the sun is high in the sky, producing a bright, even light, with very few bold shadows. But in the late afternoon, with the sun low in the sky, creating strong shadows and interesting silhouettes, those "dull" rocks may take on unexpected drama: now their shapes may suddenly become dark and powerful. Conversely, the brilliant, transparent blues and greens of the waves may look brightest at midday and lose their fascination in late afternoon, when the light is more subdued. As you walk *around* the subject, you may discover that there are lots of different ways to paint it. When you stand at one spot, you may see the tidepools framed by the shapes of the rocks. As you stand at another spot, you may see beautiful, dark reflections of the rocks in the sunlit pool.

A Note of Caution. Be sure to take along suntan lotion on sunny days, not only to protect yourself from the direct sunlight, but also from the brilliant light that shines off the water. An experienced seascape painter also travels with a hat that has a broad rim and a cord that goes under his chin to keep the hat from being blown off by the wind. Keep an eye on the tide; it can be a rude shock to set up your painting gear on a rock formation and then look down to see yourself surrounded by water!

Don't Place your horizon line at the midpoint of the picture, dividing the composition into two equal halves.

Do place the horizon line a bit above or below the midpoint of the picture. Here, the horizon line is raised slightly *above* the midpoint. Now there's room for more foreground—particularly the dramatic foreground shadow that frames the sunlit beach.

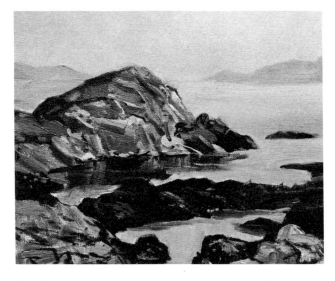

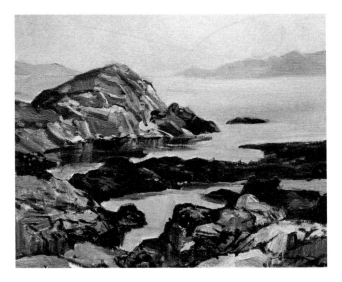

Don't place the focal point of the picture too close to the center. In this coastal landscape, the eye enters the picture through the gap between the rocks at the lower edge, then travels straight upward to the big rock formation like an arrow heading for a bullseye.

Do place the focal point of your picture slightly off center and give the eye a more interesting route to get there. Here, the big rock formation has been raised and pushed to the left. The pattern of shapes in the foreground becomes more interesting, challenging the eye to "climb" over more rocks and water to reach the focal point of the painting.

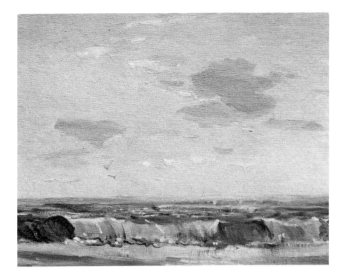

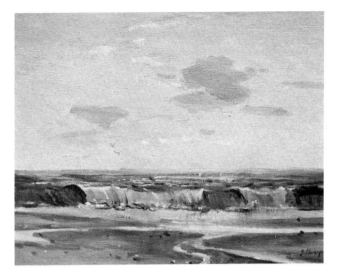

Don't drop the horizon line so far down that the sea seems to be squashed at the bottom of the painting—with mostly sky above. It's true that the coastline often seems to be dominated by sky, but it's important to include *enough* sea or shore.

Do try to arrive at a proper balance of sea and sky. Here, the waves and shore occupy the lower third of the canvas, while the sky occupies the upper two thirds. Dividing the picture into thirds is an almost foolproof method. This painting might work equally well if the sky occupied the top third of the canvas, while the sea and shore occupied the lower two thirds.

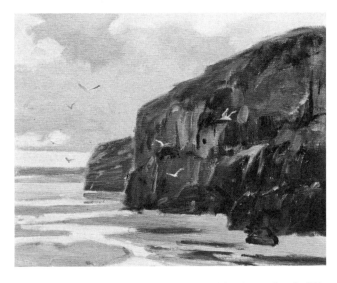

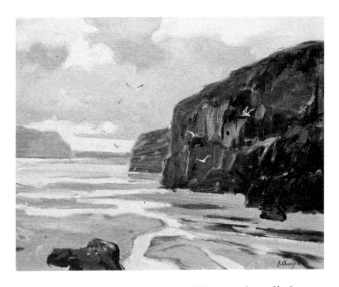

Don't become so fascinated with one big shape that it fills the canvas and allows practically no room for anything else. The dark, dramatic shape of this headland is so big that it crowds everything else out of the picture.

Do allow room for the interplay of large and small shapes. Now the big headland is balanced by the smaller shapes of a rock formation in the foreground and a smaller, more distant headland at the left. There's also more beach, which means that there's room for an interesting pattern of tidepools that lead the eye into the picture by a lively zigzag route.

Rocks in 3/4 Light. Before you begin to paint any coastal subject, observe the direction of the light and see how that light molds the forms. This is ¾ light, which means that the light is coming over one of your shoulders as you stand at the easel, facing your subject. The light strikes the rocks at an angle, illuminating the front and one side of each rock, but plunging the other side into shadow. In this particular case, the light is coming over your left shoulder.

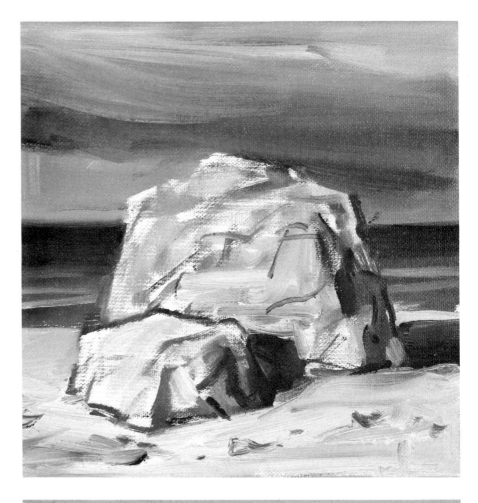

Rocks in Side Light. Here's the same rock formation at a different time of day, when the light hits the rocks from one side. Actually the sun is just a bit behind the rocks, illuminating the top and left side of each rock, but plunging the front and right side into darkness. Because the sun is to the left and slightly behind the rocks, the shadows slant diagonally to the lower right. The rocks are completely transformed by a change in the location of the sun.

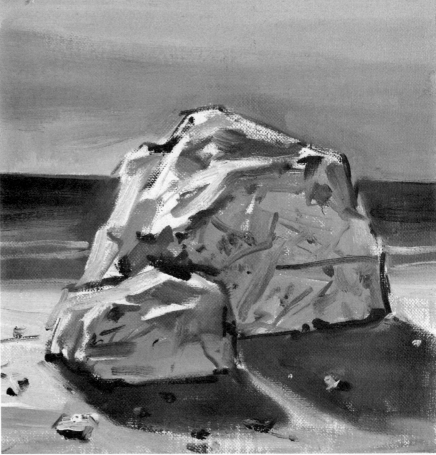

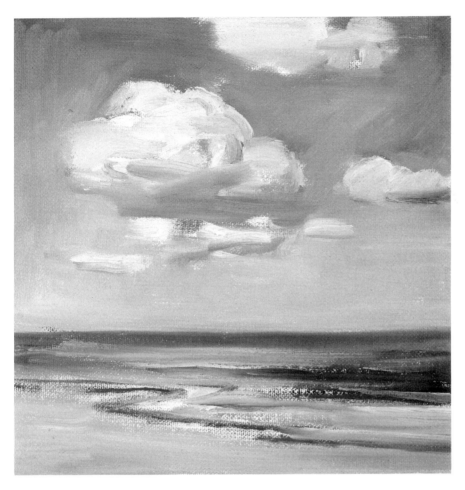

Clouds in 3/4 Light. Clouds, like rocks, have distinct planes of light and shadow. These clouds, like the rocks at the top of the preceding page, are in ¾ light. Once again, the light comes from the left, which means that the tops and left sides of the clouds are in sunlight, while the bottoms and the right sides are in shadow.

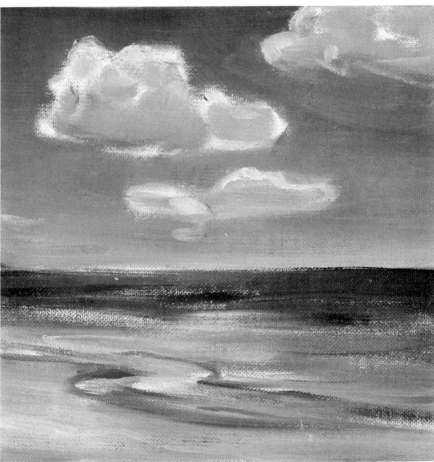

Clouds in Back Light. When the sun goes behind the clouds, their faces are in shadow, while only a bit of light creeps around the edges. This effect is common in early morning and late afternoon, when the sun is low in the sky. Not only clouds, but waves, rocks, dunes, and headlands look particularly dramatic in back light.

Waves in Perspective. Too often, we think of perspective in connection with geometric forms such as walls and highways, but we forget that natural forms also obey the "laws" of perspective. When you paint the parallel forms of waves rolling into shore, you'll paint them more convincingly if you think of the diagram below.

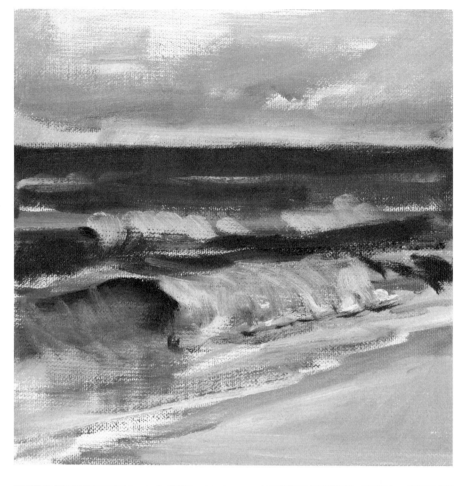

Diagram of Waves. One of the basic laws of *linear* perspective is that parallel lines tend to converge toward some unseen point in the distance. Most of us have seen this phenomenon when we look down a railroad track—but it also happens with waves. Here, the lines of the waves all seem to be converging toward some "vanishing point" somewhere off to the right. The lines are not geometrically perfect—things are always slightly askew in nature—but the waves follow these lines closely enough to create a convincing sense of space.

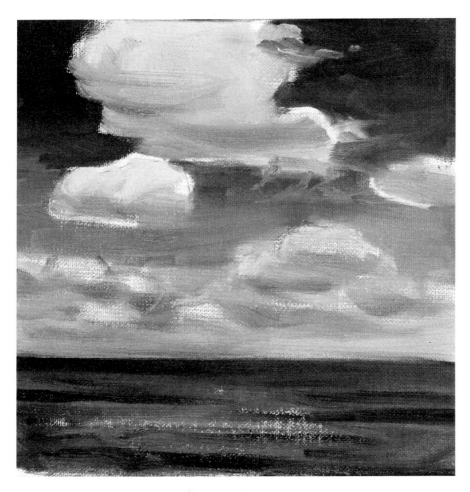

Clouds in Perspective. Another obvious "law" of perspective is that things tend to get smaller as they recede into the distance. We all know that this is true of earthbound objects like rocks and trees, but it's also true of clouds. The nearest clouds are bigger and appear highest in the picture. As the clouds grow more distant, they become smaller and they drop toward the horizon. The most distant clouds are smallest and closest to the horizon.

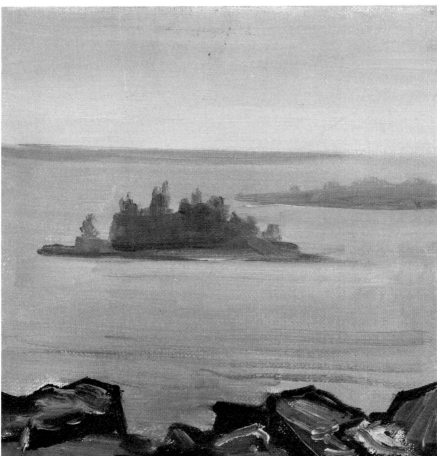

Aerial Perspective. When you're painting outdoor subjects, *aerial* perspective is even more important than *linear* perspective. According to the "laws" of aerial perspective, objects are darkest and most detailed in the immediate foreground, growing paler and less detailed as they recede into the distance. Here, the rocks in the foreground are not only darker and more detailed than the rest of the picture, but exhibit the strongest contrast between light and shadow. The distant island is paler and shows much less detail. The next island, just below the horizon is even paler and less distinct. Looking back at the demonstrations in color, you'll also see that distant objects become cooler—which means bluer or grayer.

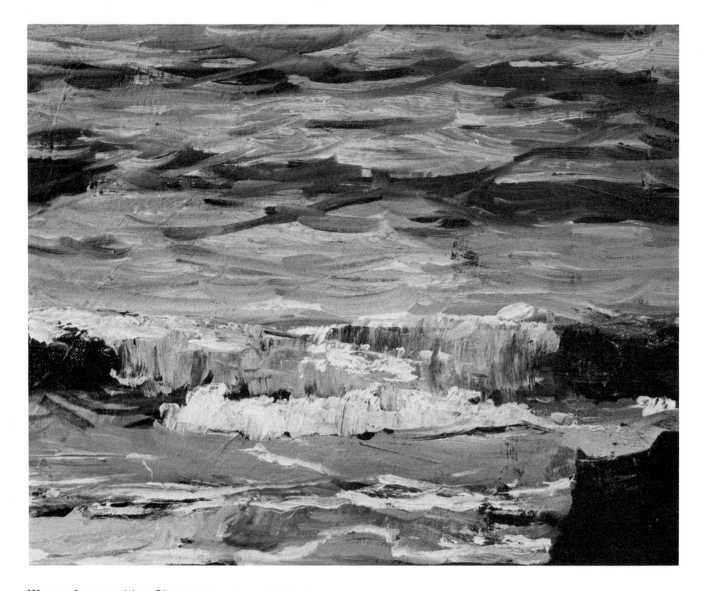

Waves Approaching Shore. When they paint the forms and movements of the sea, professional seascape painters strive to match the brushstrokes to the subject. Here's a close-up of a section of a seascape in which a variety of strokes represent the changing character of the waves. In the upper half of the picture, the choppy movement of the waves is captured by long, arc-like strokes. Bands of light and dark strokes alternate to suggest the shadowy faces of the waves and the sunlit patches of sea between them. Just below the midpoint of the picture, the brushwork changes to short, scrubby, vertical strokes that suggest the movement of the wave as it crashes downward and explodes into foam. In the immediate foreground, a smooth pool of water washes up the beach; now the paint is smoothly applied, barely showing the texture of the bristles. The tip of the brush traces the shining edge of the pool with curving strokes of thick color.

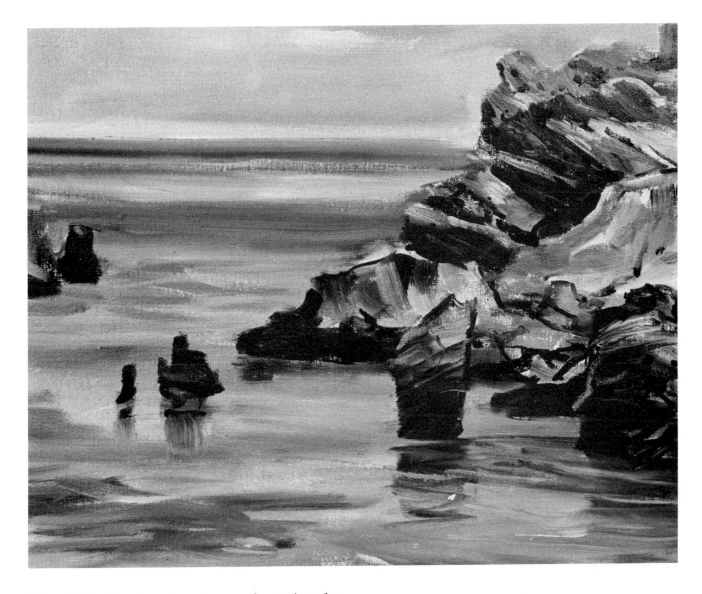

Calm Water. Here's another close-up of a section of a painting in which the brush captures the calm surface of the water with soft strokes. Beyond the rocks, the distant water is rendered with horizontal strokes of soft, creamy color in alternating bands of light and dark. As the water passes between the rocks at the left, the brushwork changes to shorter strokes that tilt slightly to suggest a few low waves. Beneath the big rock formation, the brush returns to soft, smooth, horizontal strokes that are blended into one another so that the individual stroke almost disappears to create an even, motionless surface. In the immediate foreground, some gentle ripples are suggested by shorter strokes that curve slightly, overlap one another, and alternate from light to dark. Essentially, the water is painted with long, horizontal strokes, occasionally interrupted by shorter, more active brushwork to suggest an occasional break in the smooth texture of the water. Note how the smooth, horizontal strokes of the water accentuate the rough texture of the rocks, which are painted with diagonal strokes of thick color.

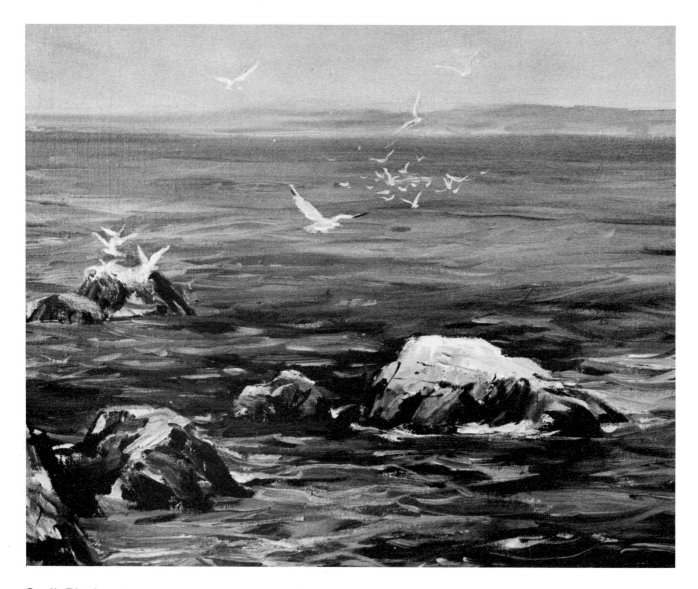

Sunlit Ripples. This close-up comes from a painting of a calm sea on a bright, sunny day, when the sunlight shines on the gently rippling water. The distant sea is painted with long, slender, horizontal strokes made by the tip of a long, resilient bristle brush—most likely a filbert. The paler strokes suggest the light shining on the water. Closer to the shore, the bristle brush paints the broad tones of the water with shorter horizontal strokes that suggest individual waves. Then the tip of a round softhair brush moves over the water, making short strokes of pale color that suggest brilliant sunlight gleaming on the ripples. In the immediate foreground, the slender strokes of the round brush curve slightly and overlap to suggest the gentle movement of the waves moving into shore. In contrast with the delicate brushwork of the water, the rocks are painted with rough, diagonal strokes of thick color. The strategy is always to orchestrate the brushstrokes—playing one type of brushwork against another.

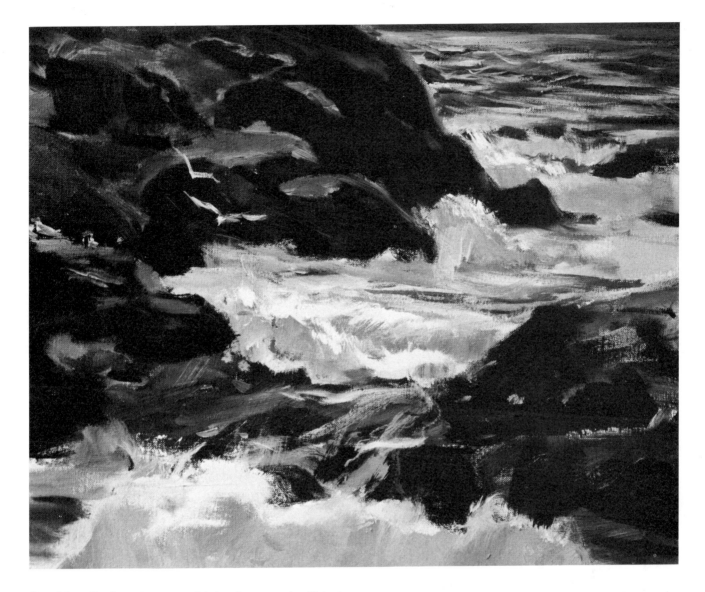

Crashing Surf. In the upper righthand corner, the distant sea is painted with slender, choppy, strokes made by the tip of a round brush to suggest the action of the waves before they strike the rocks. Then, as the waves crash against the rocks, the brushwork changes dramatically. The crashing foam is painted with vertical and diagonal strokes of thick color, applied with a stiff bristle brush that captures the erratic movement of the surf as it splashes between the rocks. The brushwork is scrubby and erratic, like the action of the surf itself. In contrast with the rough brushwork and thick color of the surf, the surrounding rocks are painted with smoother, creamier color, applied in horizontal and vertical strokes. The smoother, more solid tones of the rocks contrast nicely with the scrubby, irregular brushwork of the surf.

Swells. It's helpful to memorize the different types of waves so that you can identify them when you start to paint. In the open sea, before the waves approach the shore, they're called swells. The sea is a rhythmic series of ridges and valleys with sunlight shining on the ripples.

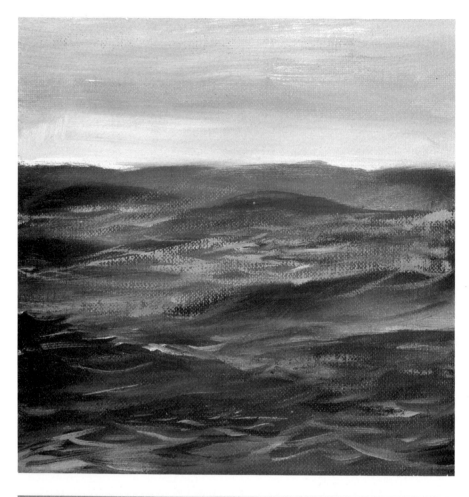

Whitecaps. In a high wind or a storm, the wind whips the tops off the swells. The foamy edges of the swells are called whitecaps. The action of the water tends to be more violent: the waves curve upward, and their faces become darker and more shadowy. It's important to distinguish between whitecaps and real surf—which is caused by the wave exploding into foam as it approaches shore.

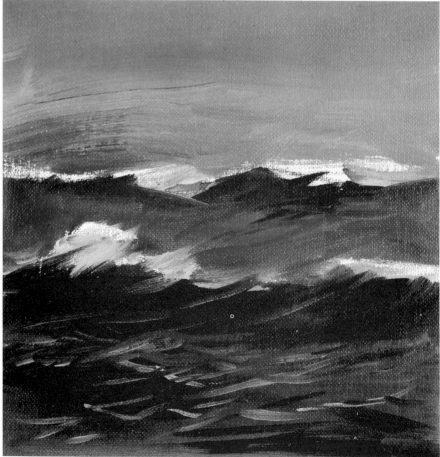

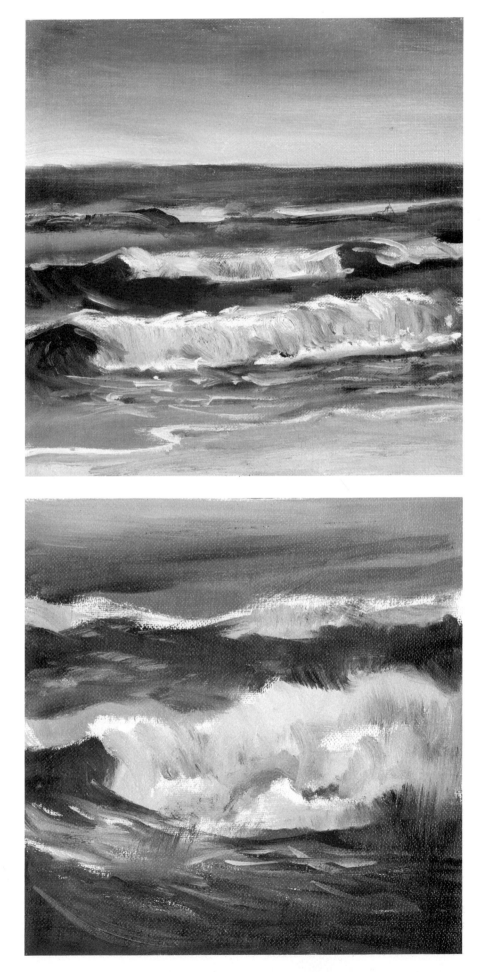

Breakers. As the ocean waves approach the shore, they surge upward and then curve forward. The leading edge of the wave curves over and explodes into foam. After the wave breaks, the water continues to move, forming a shallow pool that spills forward across the beach.

Surf. Here's a close-up of two waves exploding into surf. The leading edge of the more distant wave is just beginning to break as the wave curves forward. The foreground wave has already curved over and struck the water; the surf literally seems to explode, moving upward in a thick burst of foam. Notice how the foam in the foreground is painted with short, vertical strokes of thick color. It's also important to remember that foam has a distinct pattern of light and shadow, just like a cloud. This foam divides into several distinct shapes, with sunlit tops and shadowy faces. The surf on the distant wave is also sunlit at the top.

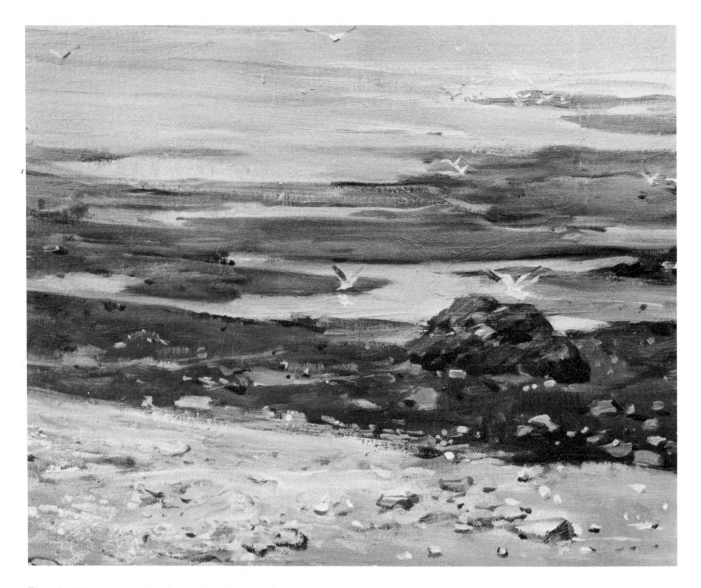

Beach. When you paint the varied forms and textures of the shore, it's important to plan your brushwork as carefully as you plan the strokes of the water. In this close-up of a section from a painting of tidepools, the sand and water become alternating bands of light and dark. The big horizontal shapes are all painted with horizontal strokes of creamy color. The distant water is painted with smooth, fairly thin color. But as the brush approaches the beach in the foreground, the color becomes thicker and the strokes become rougher. A small bristle brush and a round softhair brush paint dots and dashes of thick color across the foreground to suggest pebbles and other shoreline debris. The one big rock displays a totally different kind of brushwork: short, diagonal strokes of thick paint that express the blocky shape and contrast very effectively with the smoother texture of the sand and water.

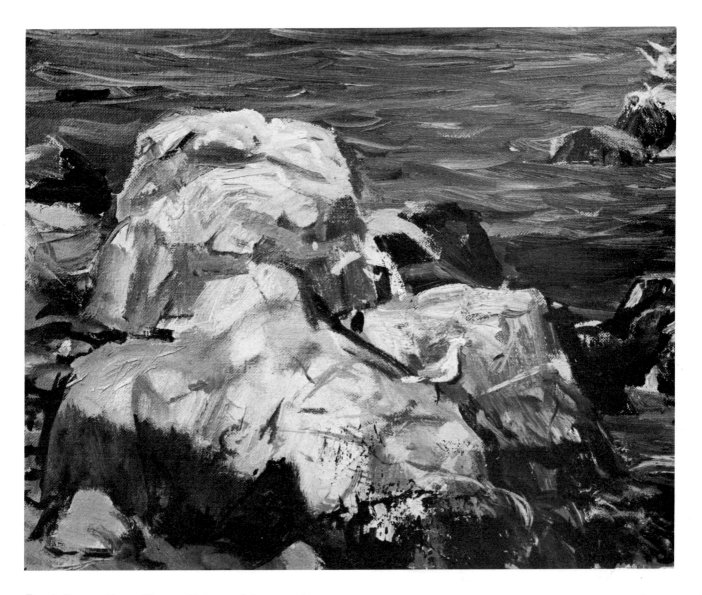

Rock Formation. The sunlit tops of these rocks are painted with horizontal and diagonal strokes of thick color undiluted with painting medium. In contrast, the shadowy sides of the rocks are painted with vertical strokes of thinner, darker color. The tip of a round softhair brush draws the cracks and other details in the rocks. This same brush suggests the ripples in the distant water with short, slender, curving strokes. As you can see, the experienced painter not only plans his brushwork, but also plans the consistency of the color.

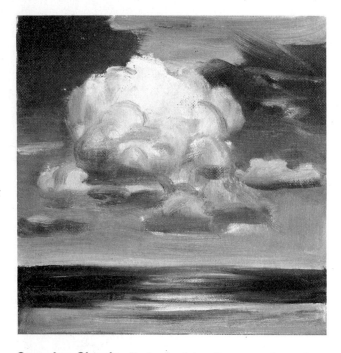

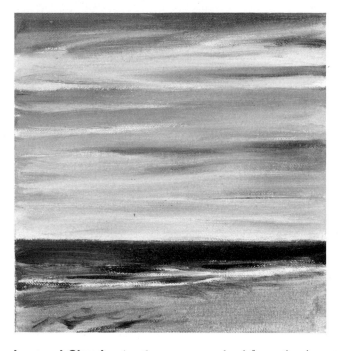

Cumulus Clouds. Each cloud has its own unique character, so it's important to learn to recognize the different types of clouds. These huge, rounded forms are called cumulus clouds. They tend to occur in clusters and move across the sky like magnificent islands. They usually have round, sunlit tops and flatter, shadowy undersides.

Layered Clouds. Another common cloud formation is a series of horizontal layers. The clouds tend to form parallel bands, some light, some dark. The wind sometimes breaks up the layers and pulls them diagonally across the sky, as you can see at the very top.

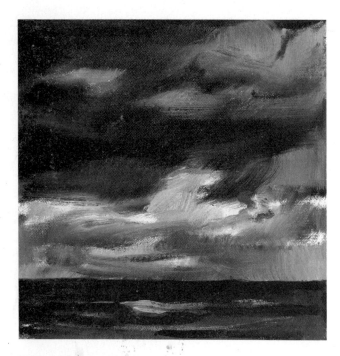

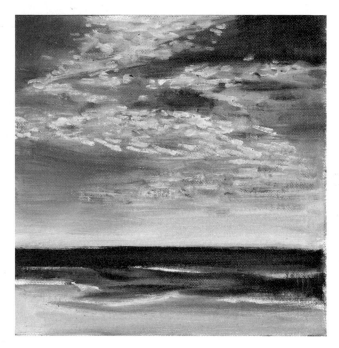

Storm Clouds. The high winds of a storm at sea can tear the clouds into ragged shapes. But even these unpredictable forms have a distinct pattern of light and shadow. The dark cloud at the top of the picture and the lighter cloud just above the horizon are surprisingly similar: each has a lighted top and a shadowy underside.

Mackerel Sky. When the wind breaks the clouds into a regular pattern of tiny puffs—like scales on a fish—this is called a mackerel sky. These puffs tend to form horizontal or diagonal clusters with strips of sky between them. Each mackerel sky has its own unique design. Never invent clouds: paint them from nature and store them in your memory bank.